Drawing CONCEPTS

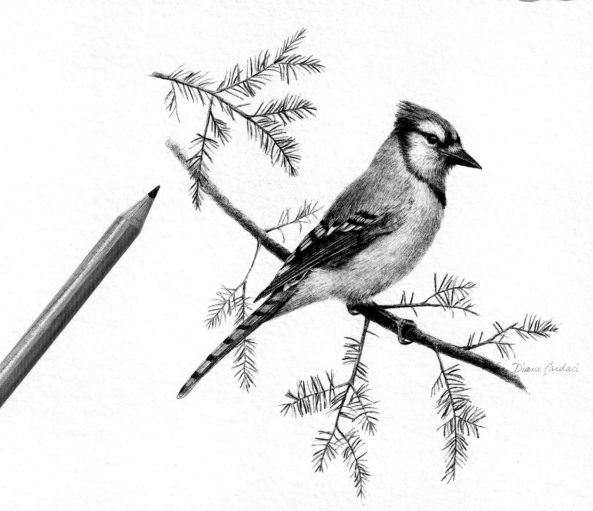

Diane Cardaci

With Diane Cardaci, Ken Goldman, William F. Powell, and Carol Rosinski

Brimming with creative inspiration, how-to projects, and useful information to enrich your everyday life, Quarto Knows is a favorite destination for those pursuing their interests and passions. Visit our site and dig deeper with our books into your area of interest: Quarto Creates, Quarto Cooks, Quarto Homes, Quarto Lives, Quarto Drives, Quarto Explores, Quarto Gifts, or Quarto Kids.

First published in 2021 by Walter Foster Publishing, an imprint of The Quarto Group.
26391 Crown Valley Parkway, Suite 220, Mission Viejo, CA 92691, USA.
T (949) 380-7510 **F** (949) 380-7575 **www.QuartoKnows.com**

Walter Foster Publishing titles are also available at discount for retail, wholesale, promotional, and bulk purchase. For details, contact the Special Sales Manager by email at specialsales@quarto.com or by mail at The Quarto Group, Attn: Special Sales Manager, 100 Cummings Center, Suite 265D, Beverly, MA 01915, USA.

ISBN: 978-1-60058-898-3

Digital edition published in 2021
eISBN: 978-1-60058-899-0

Proofreading by Johanie Martinez-Cools, Tessera Editorial

Printed in China
10 9 8 7 6 5 4 3 2 1

CONTENTS

TOOLS & MATERIALS

One of the great things about drawing is that you can do it anywhere, and the materials are inexpensive. You do get what you pay for, though, so purchase the best you can afford, and upgrade your supplies whenever possible. All you really need to start are a pencil, eraser, and paper, but there are a few other items that will come in handy as well.

PENCILS

Artist's pencils (A) contain a graphite center ("lead") and are sorted by hardness ("grades"), from very soft (labeled 9B) to very hard (labeled 9H). You don't need a pencil of every grade when you first begin drawing; a good starting collection for this book is 6B, 4B, 2B, HB, B, 2H, 4H, and 6H. Pencil hardness is not standardized, so when buying this first group of pencils, make sure they are all the same brand. Lead holders (B), which take lead refills, are an alternative to wooden pencils. Usually made of metal and plastic, lead holders are convenient and easy to use but less economic than wooden pencils.

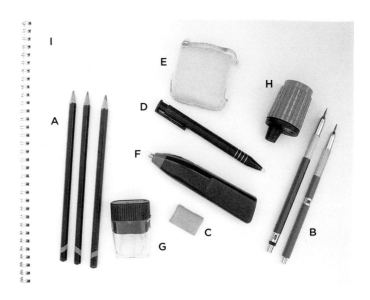

Purchasing the Essentials Your local arts and crafts store is sure to carry the basic items shown above. Keep in mind that it's best to purchase the highest quality materials you can afford, as these produce the best results.

ERASERS

There are three basic types of erasers for use in pencil drawing: kneaded (C), stick (D), and pillow (E). Kneaded erasers are very soft and can be molded into different shapes. Stick erasers come in pen-shaped holders and easily can be carved into a point using a craft knife or razor blade. Pillow erasers are made of a loosely woven cloth filled with loose erasing material, allowing you to clean up smudges and accidental marks on large areas.

PAPERS

For practice sketches, purchase a medium-weight (50- to 60-lb) paper pad, which is bound with tape or a wire spiral (I). For more finished drawings, buy a heavy-weight paper (about 70- to 80-lb). Paper texture (the "tooth") also varies: Plate or hot-pressed paper is smooth and allows for softer blends and smooth shading, whereas vellum or cold-pressed paper is rough and allows for strokes with more texture.

SHARPENERS

If you are using wooden pencils, a simple hand-held sharpener (G) that catches the shavings is a good choice. Electric sharpeners also are great, as they quickly produce a very sharp tip. If you are using lead holders, be sure to buy the appropriate sharpener for your brand (H).

BRUSHES

Brushes aren't usually thought of as a drawing tool, but they can be extremely useful for creating smooth blends and gradations and for applying graphite dust directly to the drawing surface. You can use any flat, soft-bristle paintbrush for this method. Small brushes with short bristles allow for more accuracy, so you may have to trim the bristles to the desired length with a small pair of sharp scissors.

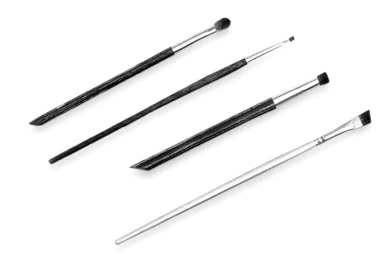

Trimming Bristles When trimming the bristles of a paintbrush, cut the bristles at a slight angle (you'll be holding the brush at an angle to the paper). The trimmed brush has stiffer bristles that give you much more control when working with graphite.

EXTRAS

A blow bulb comes in handy for blowing away loose graphite dust and eraser crumbs without disturbing the drawing (A). A small craft knife is an ideal tool for shaping erasers (B). A blending stump—soft paper packed into the shape of a slim cylinder—helps smearing and blending (C). Emery boards allow you to sharpen pencils and create piles of loose graphite (D). Pencil extenders add length to your short pencils so you can grip them properly (E), and spray fixative prevents smudging on your finished piece (F).

SETTING UP YOUR WORKSPACE

Set up a comfortable workspace to match your style. You may choose to stand to allow free arm movement or sit at a table for more precise work. Make sure that your body or hand will not block good lighting. Ensure good lighting with a floor lamp, desk light, or clamp-on light with a "natural" or "daylight" bulb, which mimics sunlight and is easy on the eye.

Gathering Additional Items Most of the items pictured above can be found at your local arts and crafts store. Others, such as tissues and cotton swabs, you may already have in the house.

HANDLING THE PENCIL

You can create an incredible variety of effects with a pencil. By using various hand positions and shading techniques, you can produce a world of different lines and strokes. If you vary the way you hold the pencil, the mark the pencil makes changes. It's just as important to notice your pencil point. The point is every bit as essential as the type of lead in the pencil. Experiment with different hand positions and pencil points to see what your pencil can do!

There are two main hand positions for drawing. The writing position is good for very detailed work that requires fine hand control, as well as for texture techniques that require using the point of the pencil. The underhand position allows for a freer stroke with more arm movement—the motion is almost like painting.

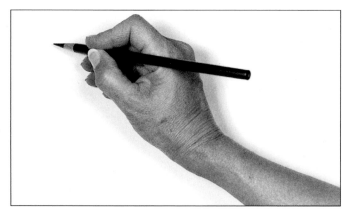

Using the Writing Position This familiar position provides the most control. Hold the pencil as you normally do while writing. The accurate, precise lines that result are perfect for rendering fine details and accents.

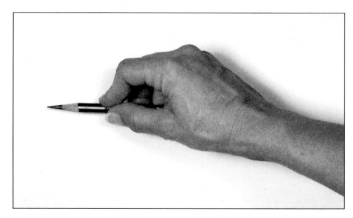

Using the Underhand Position Pick up the pencil with your hand over it, holding the pencil between the thumb and index finger; the remaining fingers can rest alongside the pencil. You can create beautiful shading effects from this position.

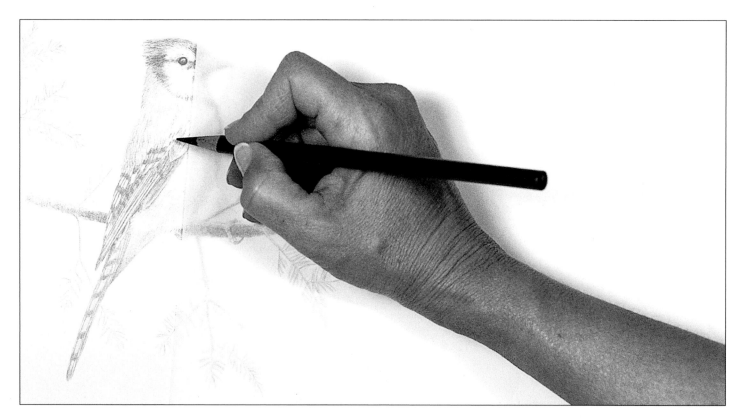

Protecting Your Art Use a piece of tracing paper as a barrier between your hand and your drawing. The tracing paper not only prevents you from smudging your drawing, but it also keep oils from your skin from damaging the art.

PRACTICING LINES

When drawing lines, it is not necessary to always use a sharp point. In fact, sometimes a blunt point may create a more desirable effect. When using larger lead diameters, the effect of a blunt point is even more evident. Play around with your pencils to familiarize yourself with the different types of lines they can create. As you experiment, you will find that some of your doodles will bring to mind certain imagery or textures. For example, little Vs may bring birds to mind, or wavy lines might suggest water.

Drawing with a Sharp Point
Make every kind of stroke you can think of, first using sharp point. Practice the strokes at right to help you loosen up.

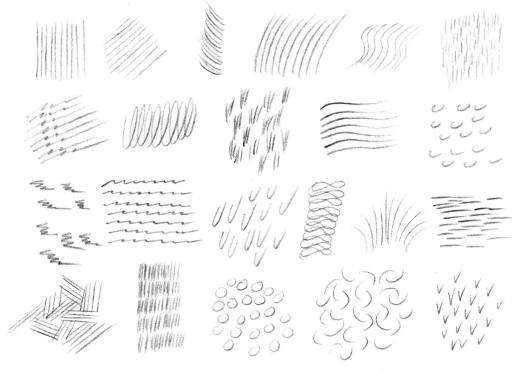

Drawing with a Blunt Point
Take the same exercises and try them with a blunt point. Even if you use the same hand positions and strokes, the results will be different when you switch pencils. Take a look at the examples at right.

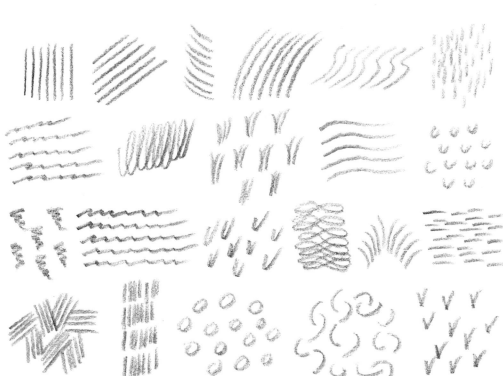

SHADING TECHNIQUES

As you'll see in Chapter 1, value is essential in suggesting the form, or three-dimensional quality, of a subject. There are many ways to apply and manipulate graphite on your paper to create a range of values, but how you apply the graphite is what determines the texture of the subject. Explore the techniques on the following pages so that you can learn a variety of shading styles and pair the appropriate technique with a subject.

HATCHING AND CROSSHATCHING

The most direct way to lay down a layer of graphite to create a darker value is by simple hatching, which is a series of parallel strokes. If you squint your eyes and look at a hatched area, the lines seem to mix together to form a value that is darker than the paper yet lighter than the actual lines of graphite. The closer you place the parallel strokes, the darker the value.

Overlapping Lines A simple way to create a darker value using hatching (upper left) is by adding the same pattern of lines perpendicular to the first layer of hatching (lower right). This is called "crosshatching." Crosshatching is a quick, all-purpose way to add value and texture to a drawing.

Using the Side of the Pencil Create a softer look by hatching with the side of your pencil (upper left). Darken the area more by crosshatching over it (lower right). This type of hatching might be a good choice for drawing a lightly textured cloth or a field of weeds.

Varying Values Loose hatching, with the lines spread far apart (upper left), is best for areas of light value. Tight hatching, with closer lines, creates a darker area (lower right).

Making Scribbles Make an even, but rough-textured, scribble hatch (upper left) and then crosshatch (lower right) for a seamlike quality that might be used to draw loosely woven fabric, mesh, or basketry.

Combining Methods Use loose, uneven scribble movement to hatch and crosshatch. This yields an interesting texture that would be perfect for rendering distant foliage.

APPLYING SMOOTH HATCHING

Although hatching with bold, rough strokes is great for quickly identifying areas of shading in a sketch, applying finely hatched lines yields a more finished look. This technique is called "smooth hatching." Smooth hatching takes a bit of practice to master, but it is essential for creating gradations that suggest evenness of texture, curvature, and form. Like so much of drawing, your ability to make a smooth hatch will improve as you gain more control over your tools.

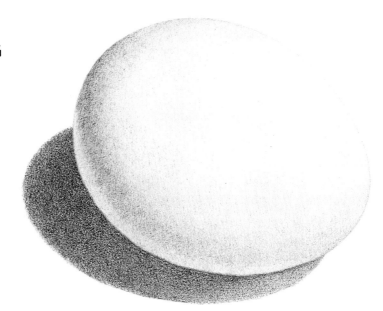

Mastering Smooth Hatching After some practice, you will be able to create a tight hatch that needs no further smoothing or blending with stumps or brushes, as demonstrated with this egg.

BUILDING UP FORMS

Values tell us even more about a form than its outline. *Value* is the basic term used to describe the relative lightness or darkness of a color. In pencil drawing, the values range from white to grays to black, and it's the variation among lights and darks (made with shading) and the range of values in shadows and highlights that give a three-dimensional look to a two-dimensional drawing. Once you've established the general shape and form of the subject using basic shapes, refine your drawing by applying lights and darks. Adding values through shading allows you to further develop form and give depth to your subject, making it really seem to come to life on paper!

Shape The first step is to draw the basic shapes of your subject. Circles, rectangles, squares, and triangles make up the basic shapes of just about anything you will draw.

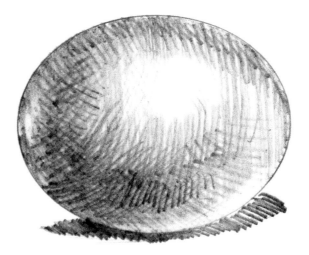

Form Because your subject also has depth and dimension, or form, you will need to make those initial circle, rectangle, square, and triangle shapes into spheres, cylinders, cubes, and cones. Sketching the shapes and developing the forms is the first step of every drawing. After that, add values to further develop the form.

UNDERSTANDING THE PROPERTIES OF PENCILS

Two important factors to consider when creating a value with graphite are the degree of hardness of the pencil and the sharpness of the tip. It's much easier to create a dark value with a soft pencil than with a hard one, and the softer pencil will leave a rougher-looking texture when stroked over the grain of the paper. The diverse looks created by different grades of lead can be used to mimic textures of objects in your drawings. Also try creating samples with both sharpened and dull pencil points; you'll see that the sharper the pencil, the darker your value will be, even when you're using the same amount of pressure.

Sharp B pencil, medium pressure

Dull B pencil, medium pressure

2B pencil, medium pressure

Dull 2B pencil, medium pressure

Using Sharp and Dull Points Sharpen a B pencil to a very fine point and fill a box using medium pressure (top left). As your pencil dulls, create another box using the same pressure (top right). You will see that the sharpness of the lead creates different values and textures. The second row above shows the same exercise done with a 2B pencil.

Affecting Value Through Grade Each of these graduated samples is made with a different grade of lead (from left to right): 4H, 2H, B, 2B, and 4B.

CHANGING GRADES TO ACHIEVE A DARK VALUE

Although it's easier to create a dark value with a soft lead than with a hard lead, you'll find that the soft lead actually skips over parts of the paper, leaving behind little white spots that dilute the value. It's tempting to just press harder with the pencil to achieve a dark value, but this only flattens the grain of the paper, creating an especially shiny and distracting spot on your drawing. To create a very dark value without flattening the grain of your paper, first go over the area several times with a very sharp, soft lead, using light to medium pressure. Follow this with a slightly harder, sharp lead. The harder lead pushes the previously applied, softer graphite into the grain of the paper that was skipped over before, so the entire area is coated; there won't be any white areas or shiny spots.

Layering First shade with a soft lead (7B). Then use a slightly harder lead (4B) to go over the top half using the same pressure. Compare the two areas and notice the effect of the hard lead on the value.

Hard over Soft Apply 7B first in the top two thirds, followed by 2H in the bottom two thirds. The center area of overlap shows how hard lead applied over soft lead darkens the value.

Soft over Hard Apply 2H first in the bottom two thirds, followed by 7B in the top two thirds. The center area of overlap shows how soft lead doesn't stick on surfaces coated with hard lead.

DRAWING WHAT YOU SEE

Most people are accustomed to drawing what they think they see, which is simply the idea of the object in our minds. Our brains aren't accustomed to recording detailed observations, so we must concentrate on retaining and recalling details for our drawings. Practice drawing what you see.

Portable Window Create a portable window from a piece of rigid acrylic, you can purchase from your local hardware store. Try the same window outline exercise indoors; it will help you understand how to reproduce the challenging angles and curves of your subject.

Window Outline Exercise To train your eye and brain to observe, stand or sit in front of a window and trace the outline of a tree or car onto the glass with an erasable marker. If you move your head, your line will no longer correspond accurately with the subject, so try to keep it still.

Foreshortening in a Window Drawing *Foreshortening*—when an object is angled toward the viewer—causes the closest parts of an object to appear much larger than parts that are farther away. This can be a difficult concept to master, so practice with window drawings.

Looking at Photos Another beneficial way to observe impartially is to find an interesting photo and outline the shapes and values you see with a pen. Take your time and indicate even the smallest change in value.

MEASURING WITH A PENCIL

Drawing the correct proportions—the size relationships between different parts of an object—is easier if you learn to take measurements directly from your subject and then transfer those to your paper. You can measure your subject with just about anything (for example, your thumb). Using a pencil is an easy and accurate way to take measurements, as shown below.

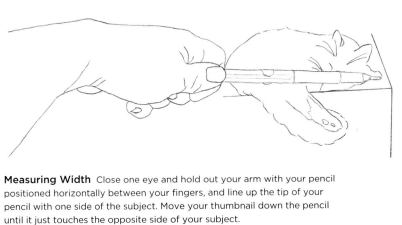

Measuring Width Close one eye and hold out your arm with your pencil positioned horizontally between your fingers, and line up the tip of your pencil with one side of the subject. Move your thumbnail down the pencil until it just touches the opposite side of your subject.

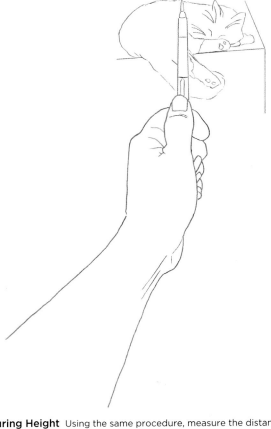

Transferring Measurements Mark the length of your pencil measurements on your paper. If you want to enlarge the subject, multiply each measurement by two or three. If you extend the initial markings to this new measurement, you can form a box around your subject that will work like a grid to help you draw your subject using correct proportions.

Measuring Height Using the same procedure, measure the distance between the highest and lowest points of your subject.

Adding Up the Numbers After you've created the basic rectangle, sketch the subject's general shape within the rectangle. Keep the shape simple and add details later.

Mapping Out Elements As long as you stay in the same position with your arm extended at full length, you can take additional measurements.

Correcting Calculations While progressing from a basic shape to a gradually more detailed outline drawing, take measurements before applying any marks to keep your drawing in proportion.

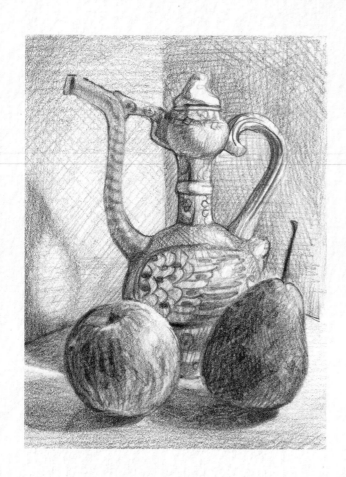

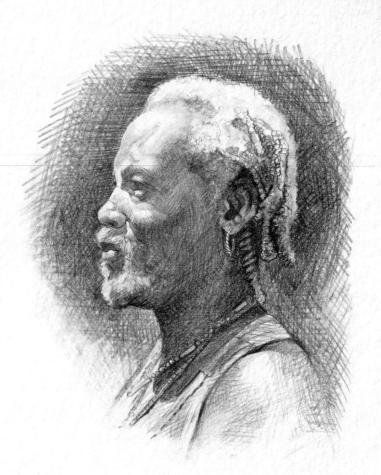

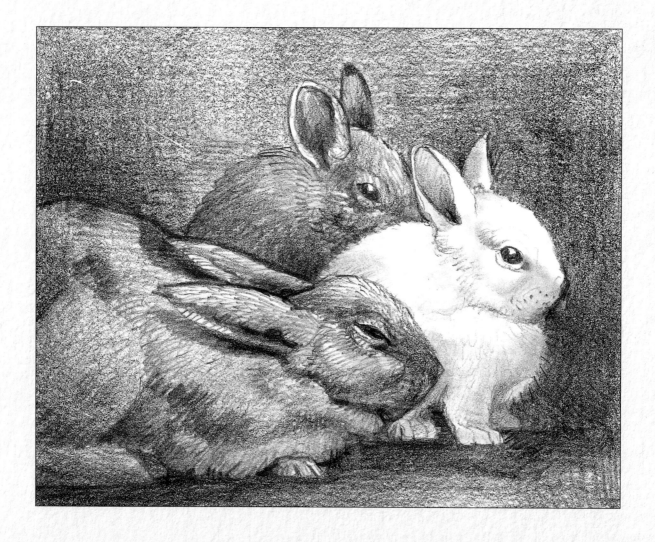

UNDERSTANDING VALUES

WITH KEN GOLDMAN

This is not just a "how-to" chapter; it is a "how-to-see-and-do" chapter. When seeing and drawing shapes and their values—lightness or darkness—you are not drawing "things." Rather, you are creating areas of value as various shapes; those shapes become recognizable only when they are drawn accurately in combination with other shapes. This is an effective, time-tested approach, but its application requires some rethinking of childhood drawing preconceptions, as well as discipline in seeing and drawing differently. The exercises in this chapter will take you through a step-by-step process of seeing shapes, identifying their light and dark values, and fitting the pieces together to form recognizable images. By seeing and drawing objectively, rather than by thoughtlessly copying, you will be able to create a realistic subject.

—Ken Goldman

PRACTICING BASIC STROKES

The moment your pencil touches paper, you have made a statement. Value, line, texture, and shape are elements that you, the artist, can use to convey ideas. In the drawing below, the various strokes create a rabbit sitting alertly in a field. In artistic terms, the recognizable shape is a rabbit, surrounded by various combinations of textures, values, and lines that tell us about the field. Practice these strokes and note how and where they are used throughout this chapter.

Adding Texture Note the effect created in the drawing by each basic stroke shown here. Experiment with a blending stump to see which additional textures you can create.

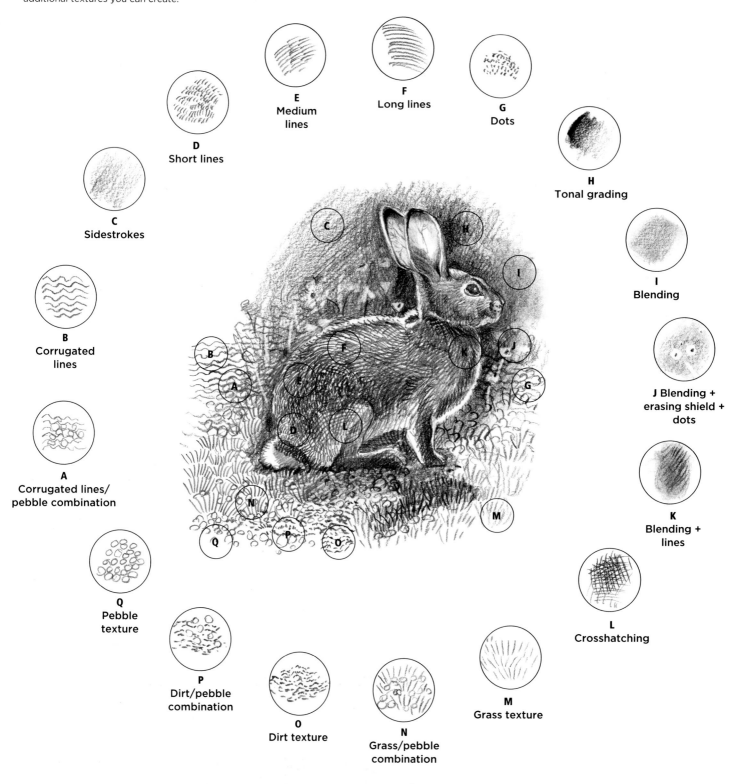

E
Medium lines

F
Long lines

G
Dots

D
Short lines

H
Tonal grading

C
Sidestrokes

I
Blending

B
Corrugated lines

J Blending + erasing shield + dots

A
Corrugated lines/ pebble combination

K
Blending + lines

Q
Pebble texture

L
Crosshatching

P
Dirt/pebble combination

M
Grass texture

O
Dirt texture

N
Grass/pebble combination

UNDERSTANDING VALUE & SHAPE

Value is defined as the relative lightness or darkness of a color or of black. In nature, values have infinite gradations, or degrees. The shapes that we see are a result of these changes in value. Because artists cannot visually comprehend such unlimited subtleties, they reduce nature's vast scale into values that they easily can see. Many artists use a scale of nine values ranging from black through gray to white. Sometimes only five may be used: highlight, light, medium, dark, and low dark.

ESTABLISHING A VALUE SCALE

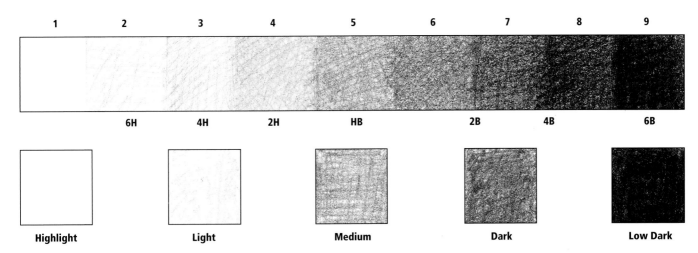

Rendering Values The nine-value scale shows the transition from white through gray to black. The numbers and letters underneath the scale show you the pencils used for each value. The 6H is the hardest lead and barely makes a mark; it works well for delicate shading, such as value 2. The 4H is slightly softer and, depending on how much pressure you apply, will create values 2, 3, and 4. The 2H is good for light lay-ins; it works well for value 4, and its soft lead will not leave grooves in fragile paper. The HB is a great pencil for all-around drawing, and it's perfect for the middle-value 5. The 2B has a wide range: It represents values 6 and 7 on the scale. The 4B is a soft, dark pencil that corresponds to values 7 and 8 on the scale. The 6B is slightly darker than the 4B; it creates a velvety black corresponding with value 9, but it easily breaks when being sharpened.

RECOGNIZING SHAPES

Basic Shapes For non-artists, a shape is an object with a label, such as an apple, a vase, or a bird. However, artists attempting to draw these objects need to learn new ways to analyze these shapes.

Shaded Shapes Imagine a silhouette of an apple. A non-artist recognizes it by its shape. But artists need to go further. Artists need to look closely at the shapes of light and dark values that form on the surface of the apple and then give those shapes names. In this way, artists can observe, analyze, remember, and draw what they actually see.

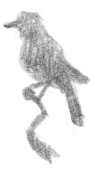

SEEING VALUES

There is a saying among artists: "Color gets all the attention while value does all the work." Whether you draw an object with a two-, five-, or nine-value scale, it is value, not color, that is mainly responsible for the visual strength of the image. With practice, you can train yourself to view objects and scenes in terms of their values.

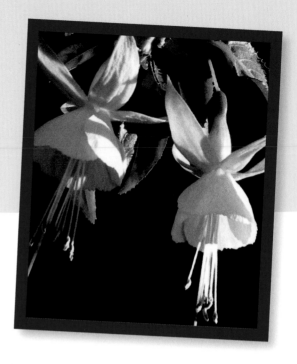

Translating Color to Value This photo of fuchsia was shot in brilliant color. But the range of values is what gives the image strength in black and white.

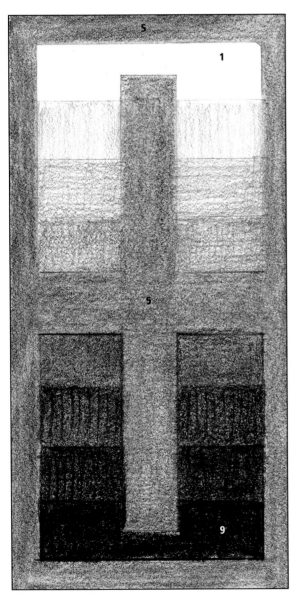

Recognizing Contrasts An artist can achieve a wide range of contrasts with the help of *simultaneous contrast*—the illusion that a middle-value (5) gray appears darker when surrounded by white (1) and lighter when surrounded by black (9). The middle-value gray column and border in this image actually have the same value from top to bottom and all around.

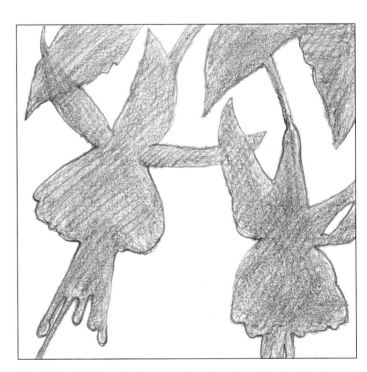

Simplifying Values The first stage in seeing values is to simplify. Two values (white and a middle-value 5 gray) are perfectly adequate to convey the idea of this fuchsia.

18

USING LINES AS A SHORTHAND FOR VALUE

Lines do not exist in nature, but they certainly exist in drawings! Use lines as a shorthand method for transferring nature's three-dimensional world of light and dark onto two-dimensional paper.

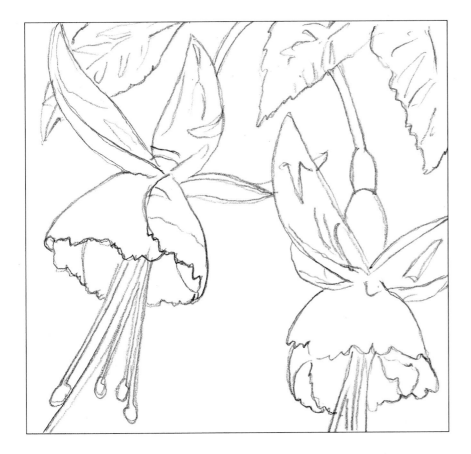

Representing Shapes with Lines The second stage in learning to see values is to find and draw the shapes within the overall form. Compare the flat, outlined silhouette on the opposite page with this line drawing. Instead of having a middle value, add internal lines that break up the large main shape of each flower into smaller shapes. This creates a linear sense of three dimensions and overlapping.

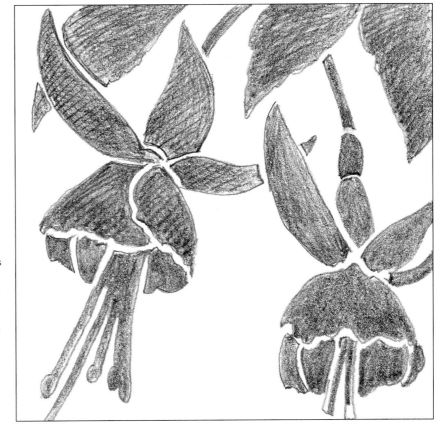

Combining Value and Line This drawing represents the third stage in seeing values. It combines the two values of the first stage with some of the lines from the second stage to further divide the shapes into smaller areas. Because this subject has the complexity of small veins, frills, and other details, it's much simpler to begin the drawing with large, simple shapes like these.

INTRODUCING A THIRD VALUE

As you begin to render additional details to the shapes of light and shadow, add a third value. This new, slightly lighter value allows you to incorporate the transitional subtleties that help give the fuchsia a sense of volume. Crosshatching and sidestrokes are two methods for building up lights and darks. Try some of the strokes and textures shown on page 16 to see the effects you can create.

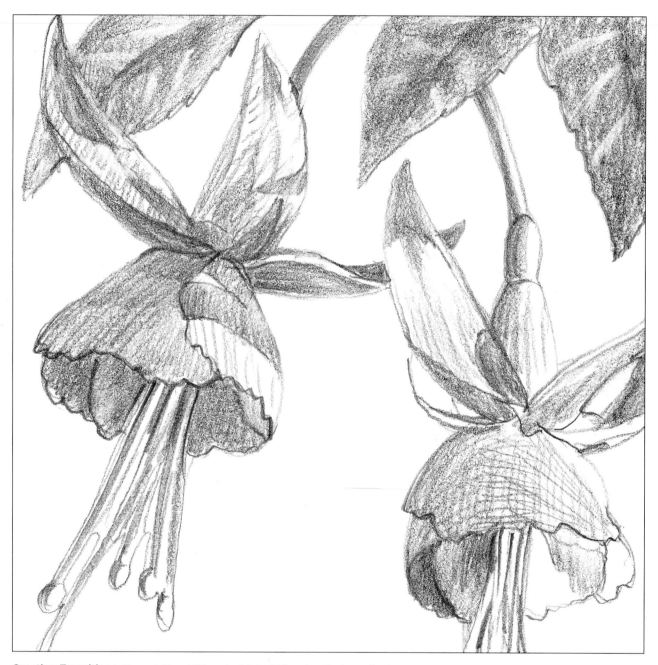

Creating Transitions Through the addition of a third middle value, the image begins to assume depth and volume. Because there are no areas darker than value 4, you can use an HB pencil for the whole drawing. The HB pencil is soft enough to make darks but also hard enough to render delicate lights, such as the outer petal of the left-hand flower and the inside petal of the right-hand flower.

Adding a Lighter Middle Value For this version of the fuchsia drawing, add value 4, one step lighter than the middle-value 5 used in the earlier drawings.

CREATING DRAMA WITH ADDITIONAL VALUES

Compare the final drawing on this page with the three-value drawing on the opposite page. This version is closer to the actual photo because of the added contrast and transition, due to the adjusted middle values (3 and 6) and the use of black (9). This is an important point: How much should an artist deviate from a reference? The answer is that it depends on what degree of "finish" an artist prefers. Some artists like to copy a photo just as it is, and that's fine. The main difference between a photographic, realistic interpretation, and the drawing on this page is that a super-realist will use the full value scale with its subtle gradations, whereas a drawing like this one uses only four values, resulting in less subtlety but more drama.

1	3	6	9

Adding Contrast The four values used for the final drawing are 1, 3, 6, and 9.

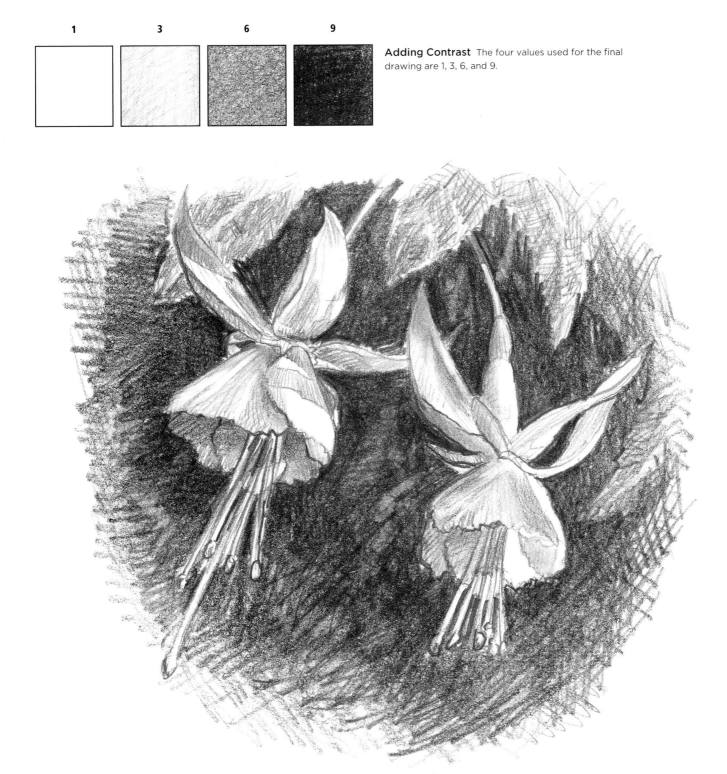

Interpreting the Subject Although the values in this drawing are similar to those in the photo, the use of looser, cross-hatched strokes makes this rendering more of an artistic interpretation than a strict copy.

PLACING SHAPES ACCURATELY

Knowing that drawing is a matter of seeing forms as shapes and values rather than preconceived objects is one thing; the next question is, "How do I find correct proportions and place those shapes accurately?" There are two techniques, in addition to measuring (as shown on page 13): seeing negative shapes, and drawing upside down.

FOCUSING ON NEGATIVE SHAPES

A non-artist can enjoy the graceful "positive shape" of this beautiful cypress tree and go no further. But an artist needs to see and be aware of the space around the cypress—the negative shape—in order to draw its outer shape. When you begin a drawing, use negative shapes in conjunction with measurement. Before evaluating the negative shapes, look for common measurements and make light construction lines.

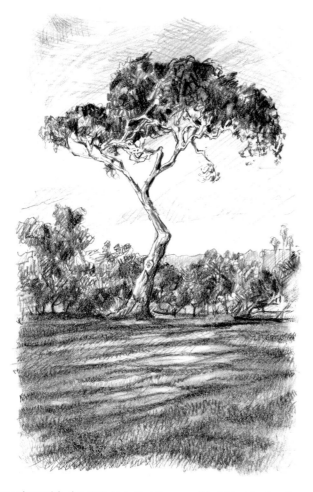

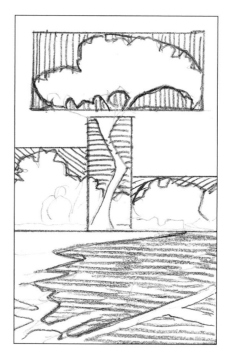

Cropping In After taking measurements to find the height and width of the cypress, simulate a grid by lightly drawing rectangles and boxes around the canopy, trunk, and distant trees. "Cropping in" like this allows you to see positive-negative shape relationships better.

Measuring with the Eye Note that the overall height of the tree is exactly the same as the width of its canopy. This will help you draw the correct proportions when transferring the tree.

Creating Atmosphere These are the values used for this drawing: 1, 3, 6, and 8. There is no value 1 because any black in the distance would destroy the illusion of atmosphere and depth. (See page 36 for more on this.)

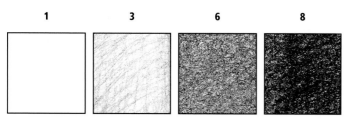

1	3	6	8

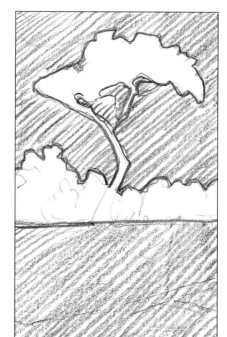

Interpreting Space The darkened sky and grass areas represent "negative" space around the trees; drawing the edge of these negative areas creates the "positive" shapes (trees). Conversely, drawing the edge of the positive trees creates the negative shapes (sky and grass).

DRAWING UPSIDE DOWN

Sometimes preconceptions are so strong that it becomes almost impossible to draw shapes and values objectively. The best solution is to turn both your reference image and drawing paper upside down. Seeing the image upside down almost immediately negates the preconceptions of what your subject should look like.

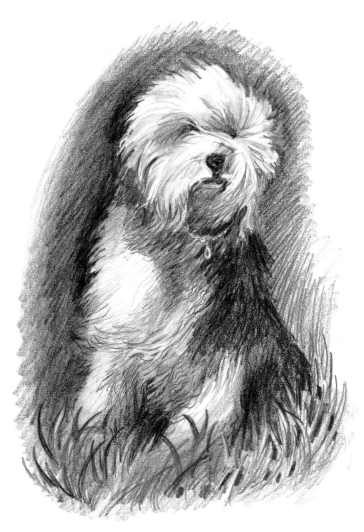

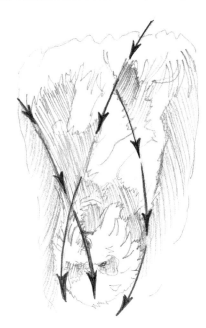

Step 1 With an HB pencil, lightly sketch the dog's basic outline using shape identification, measurement, and negative shapes.

Looking for Shapes This sheepdog is a perfect candidate for you to attempt drawing upside down because it is composed of such simple shapes. Lay in the drawing with an HB, and then use a 2B, 4B, and 6B, respectively, for lights, middle values, and darks.

Step 2 Now add the dark (positive) shapes. Note how drawing the positive shapes creates the light (negative) shapes. Also take note of the "flow," or movement, in the subject. Follow the arrows here, and then look for those flow lines in the final drawing at left. Flow lines not only help you get better proportions (as negative shapes do), but they also convey the overall rhythm in a drawing.

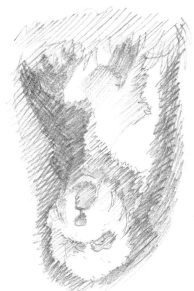

Step 3 Refine the edges of both the positive and negative shapes, and the sheepdog will miraculously begin to appear. Because you are drawing abstract shapes, upside down, you won't know just how accurate your dog really is until you turn it right-side up.

DRAWING VALUES AS SHAPES

This demonstration is a summation of all the shape- and value-seeing tools discussed so far. You can attempt copying it either right side up or upside down. If it looks too difficult, try drawing it upside down. Stick with the basics and avoid preconceptions, and you will be amazed at what you can accomplish.

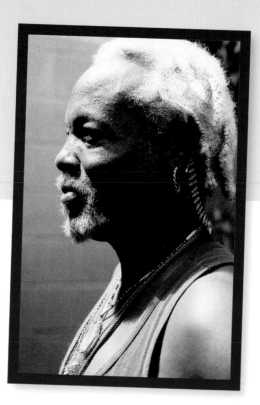

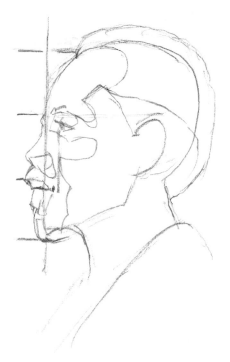

Observing the Subject Before drawing, observe your subject and look for basic shapes and measurements.

Step 1 With an HB pencil, sketch a vertical line and mark off three equal divisions: hairline to brow, brow to top of lip, and top of lip to bottom of beard. Draw the basic shape of the head and place the nose and lips on the left side of the vertical plumb line; then sketch in the shapes of the shadows.

Step 2 Erase the construction lines and carefully shade the shadow shapes. Don't bother with details at this point.

Step 3 Now render details and the smallest shapes. If you can accurately draw these shapes, you can achieve a likeness.

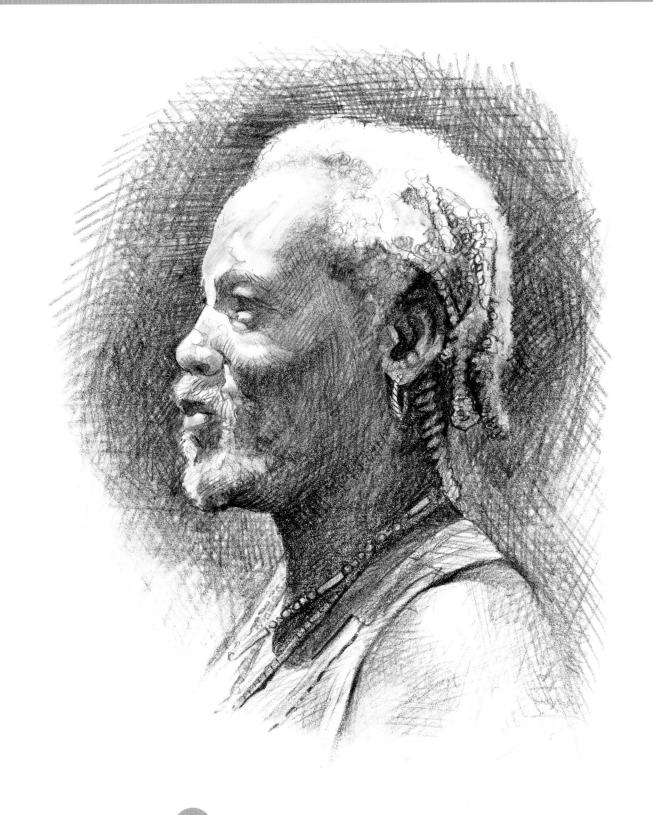

By using a stump to blend cross-hatched areas and adding crosshatching over blended areas, your strokes will convey a unified richness and direction while still remaining subordinate to the larger overall shape.

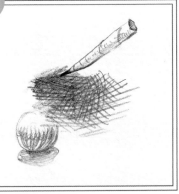

Step 4 To finish, use various strokes (especially crosshatching) and blends to suggest textures and transitions in value.

DEPICTING FORM

Light and shadow create the illusion of solidity, or form, in drawing. This exercise will help you observe the light and shadow "families," or groups of values, in any composition.

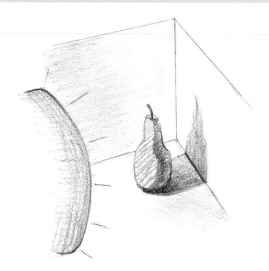

Step 1 Set up your still life box, place a pear or another object in the corner of the box, and shine a spotlight on the side of the object to create a division of light and shadow.

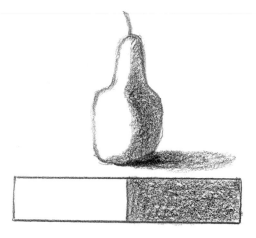

Step 2 Draw the pear with a simple division between light and shadow. The value scale below the pear demonstrates this division.

Step 3 Make another sketch of the pear, showing each plane.

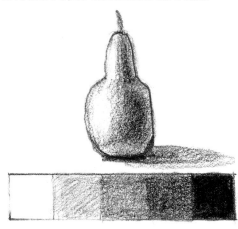

Step 4 Draw the pear again, but this time use a range of values. By adding subtle halftones between the extremes of light and dark, you can create a feeling of solid roundness.

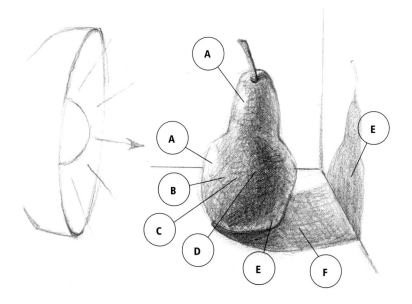

Understanding Terms This illustration shows the terms used to describe the lights and shadows that create form. The very light areas, A, are highlights (which are fairly subtle on a pear). B is a light area surrounding the highlights. C is a halftone; it forms the important visual transition between light and shadow. D is the shadow core, or the area where light ceases and shadow begins. E is reflected light, both on the wall (within the cast shadow) and on the object (along the core shadow). Without the contrast provided by reflected light on the dark side of the pear, there would be no shadow core—only shadow. F is the cast shadow, which begins dark and hard-edged and grows lighter and less distinct as it recedes from the light source and object.

DIRECTING THE EYE WITH VALUE EDGES

"Value edges," or the lines where contrasting values
meet, play an important role in directing the eye around a
drawing and holding the viewer's attention.

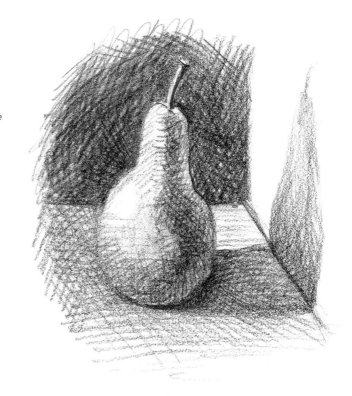

Establishing a Focal Point When value
contrast is high and hard edges dominate one
area, the viewer's eye will be directed to that
area. This area is called the "focal point," and
it should also be the center of interest.

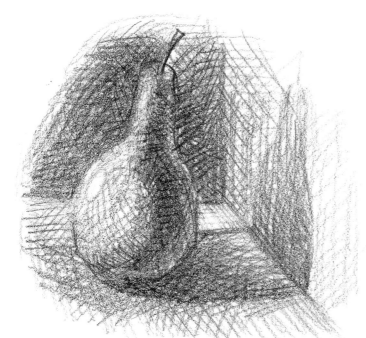

Capturing Attention Medium values and medium edges
create secondary areas of importance. A picture should
primarily contain these elements so the hard-edged focal
point will stand out and seize the viewer's attention.

Representing the Periphery Close values and soft
edges represent the periphery of vision. When you
look directly at an object, everything else is mostly out
of focus. If you keep the least important areas of your
drawing soft edged, the viewer's eye will then travel to
the hard-edged contrasts of the more important areas.

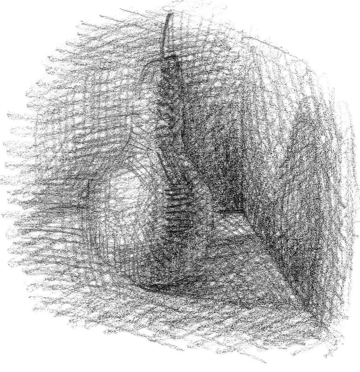

ESTABLISHING A LIGHT SOURCE

Most indoor situations have too many light sources to make a good drawing from life. Ambient light from windows, lamps, open doors, and so on produces conflicting highlights and makes it difficult to show solidity. A single, controlled light source works best.

Double Lighting Two opposing incandescent sources light this Asian teapot, creating two highlights and two vague shadows. The double lighting makes the teapot look flat.

Fluorescent Lighting Because they come from a long-wave light source, fluorescent lights tend to diffuse and soften forms. Here, the teapot is set in the same place as in the first photo, but now all the light is coming from eight-foot fluorescent bulbs above. As with other multiple light sources, the result is that the teapot still appears too flat to make an interesting drawing.

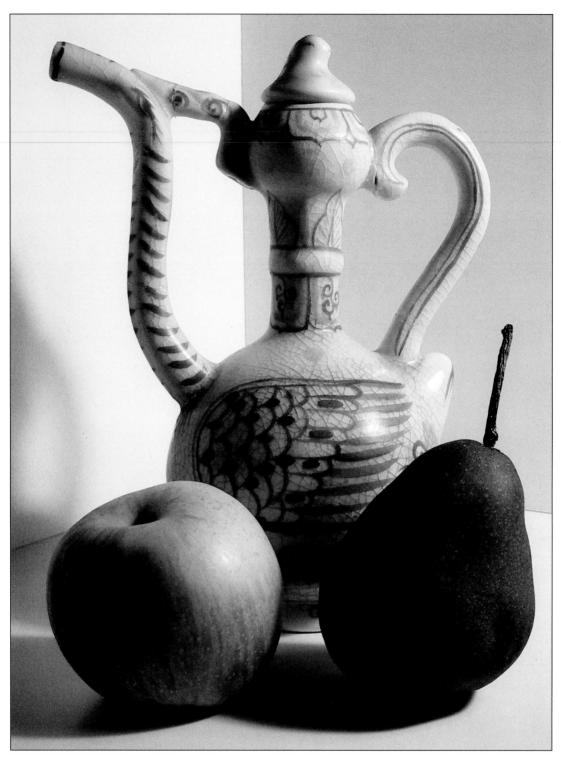

Single Lighting With the addition of an apple and a pear, there are now a variety of shapes, values, and surface types. The scene is lit from the right and slightly above. Compared to the first two setups, the light, shadows, and cast shadows here not only add a sense of volume but also create an interesting design.

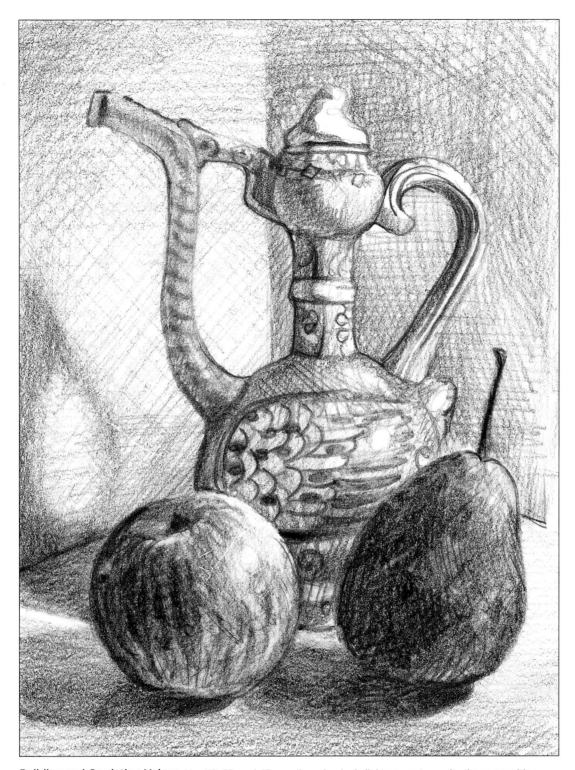

Building and Gradating Values Use HB, 2B, and 4B pencils and a single light source to render the composition. Employ crosshatching to build up values, and use underhand sidestrokes for gradated areas.

Value Scale This drawing makes use of values 2, 5, and 8.

REINTERPRETING VALUES

When an amateur photographer points a camera at a bright sky or glaring ocean and clicks, the darks in the resulting image can end up too dark, and the lights are often washed out. The optimum exposure for a camera—and for the human eye—is middle-value gray. An artist must understand this phenomenon when working from a photo and attempt to correct the values accordingly.

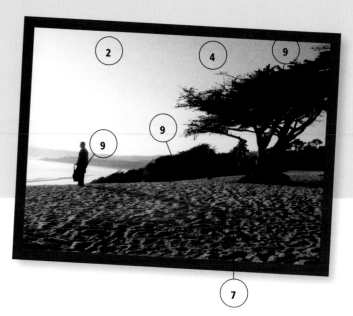

Adapting from a Photo Compare this photo with the drawing below, and note how the readjusted values in the drawing add more balance and atmosphere. The drawing includes a full range of values, but the darkest darks serve solely as accents in the tree and the human figure.

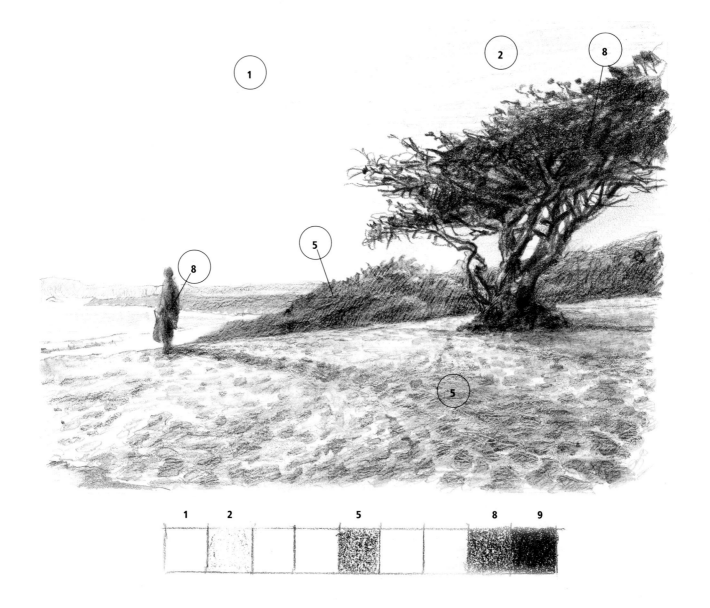

ADJUSTING VALUE "KEYS"

Like a pianist, an artist can choose any "key" and play in it. A virtuoso musician knows how to use different keys to evoke different emotions. Similarly, by using value variations, artists can convey a range of moods, from bright and cheery to dark and somber, or even portray weather conditions and times of day. Think of a value scale as a piano keyboard, with each group of numbered values representing a different key.

High Key When you keep your values on the upper (lighter) side of the scale, the effect will be that of a foggy morning. It could also evoke a dreamy, pensive feeling from the viewer. This drawing makes use of values 1, 2, and 3.

Middle Key Limiting yourself to the middle part of the scale creates the look of a cloudy day. These middle values can create a calm, soothing atmosphere. This drawing makes use of values 4, 5, and 6.

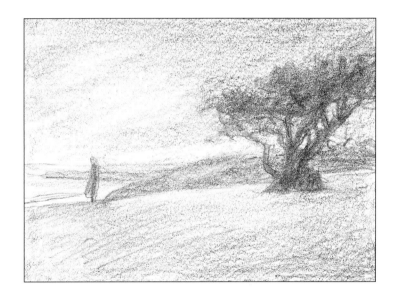

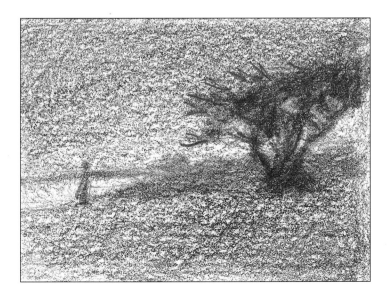

Low Key The lower (darker) part of the scale is perfect for depicting dusk, dawn, or a stormy day. Emotions elicited from this drawing could range from peaceful and tranquil to passionate and turbulent, depending on the intensity of the darks. This drawing makes use of values 7, 8, and 9.

ATTRACTING THE EYE

The eye will normally enter a drawing where the largest positive shape touches the border. If such a shape does not touch the border, the eye will jump inside the composition to the most interesting positive element. By placing your center of interest (or focal point) carefully and giving it the greatest amount of contrast, you can create visual interest and draw in the viewer's eye. From this point on, it is the artist's sense of design that will direct the viewer's eye. The eye follows paths created by (1) edges of light and dark; (2) the bulk of light or dark areas; and (3) light or dark dots, dashes, and accents.

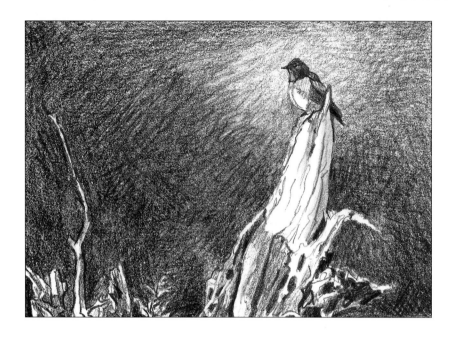

Creating a Focal Point
The viewer's eye immediately goes to the tree trunk and perched bird in this composition because they hold the greatest contrast to the medium-dark background. The background is a touch lighter behind the bird to better set off the darks.

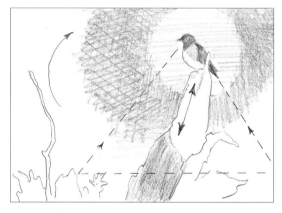

Circulating the Eye The viewer's eye travels up the thick branch to the high-contrast bird at the apex of a stabilizing triangle. Secondarily, the light branch at far left attracts the eye and holds it, and then circulates the eye back to the bird.

Directing Attention The darker rabbits blending into the background of this drawing makes the contrasting white rabbit the center of interest. Its black eye is like a visual magnet; then the beady eyes of the darker rabbits attract the viewer's attention and create a triangular flow between the three rabbits.

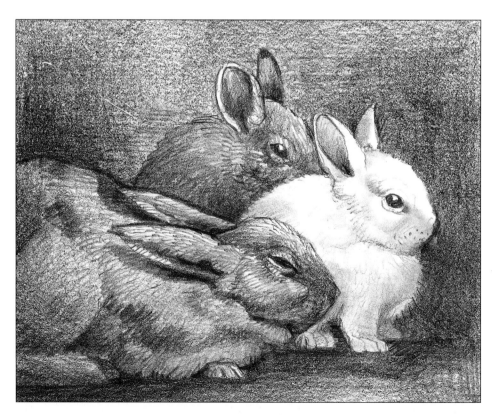

Attracting and Directing Attention In this photograph of California mission-style buildings and their surrounding gardens, light guides the viewer's eye into and through the scene. Lines, dots, and accents add interest.

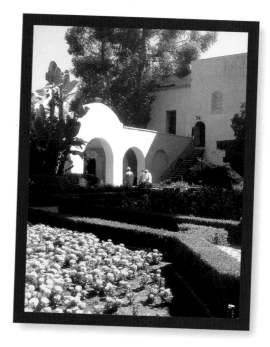

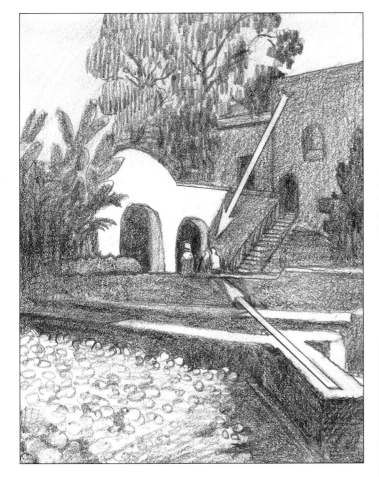

Drawing Attention Look at the photo above, and then follow the arrows in this diagram. Note that the eye enters where the foreground hedge touches a border and then moves through the shadow to the people, who act as accents. Speaking of interest, cover up the flowers with your hand, and see how much sparkle the picture would lose if they were eliminated.

Maintaining Interest Have you ever looked at a long, blank wall or an empty sky? Think of how your eye begs for something solid to focus on. Without accents and edges, the eye will simply become bored and move on to someone else's drawing. Once again look at the photo; analyze how your eye moves within it, and see if the arrows in this diagram are similar to the paths your eye follows.

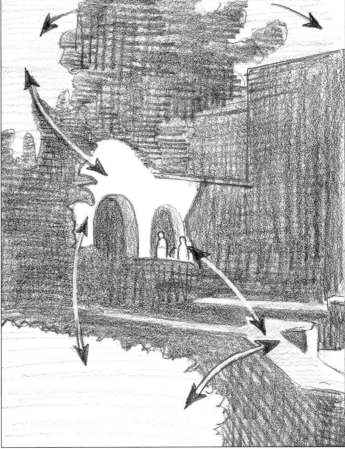

CREATING DEPTH

Linear perspective lends the illusion of dimension to a composition, but an artist has additional tools: overlapping objects, creating contrasts in value and texture, using aerial perspective, and introducing shadows.

USING SHAPES, VALUES, AND TEXTURES

The way you place values in the foreground, middle ground, and background affects the perception of depth in a drawing. Contrasting these values and their textures conveys a sense of dimension.

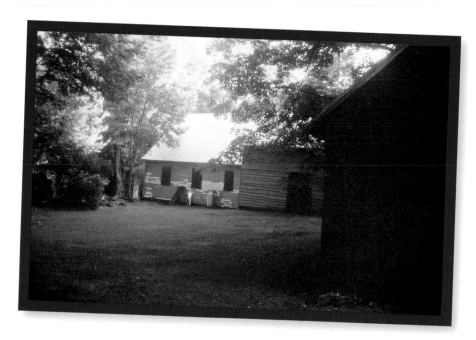

Adjusting References Although the foreground in the photo above came out too dark, this is still a usable reference photo. The thumbnail sketches below each have a different value arrangement; both sketches have a more balanced composition.

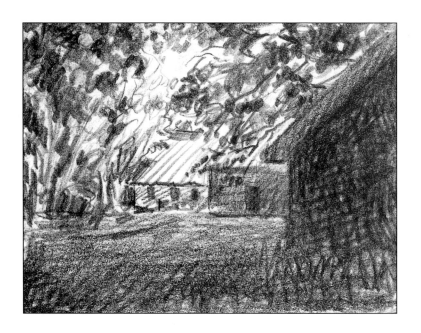

Overlapping Shapes Overlapping is an excellent way to create the appearance of depth. The addition of aerial perspective increases the illusion further. Although the composition shows depth, it still lacks interest because it remains overly true to the photograph. The composition also is unbalanced with the dark right side drawing the viewer's eye.

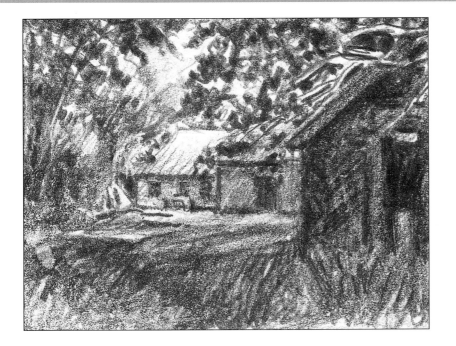

Balancing Value Contrasts Having the same value structure as the first thumbnail, this sketch has a lightened foreground shed and grassy areas, as well as an added door, window, and branches to create a balance of value contrasts throughout. After creating your thumbnails, choose the one you find more interesting, and use it in conjunction with the photo as the basis of your final rendering.

Step 1 Sketch lightly with an HB pencil to mark out the foreground shed, two distant buildings, diagonals on the ground, and general areas of foliage.

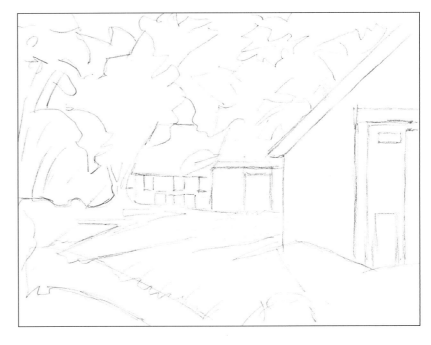

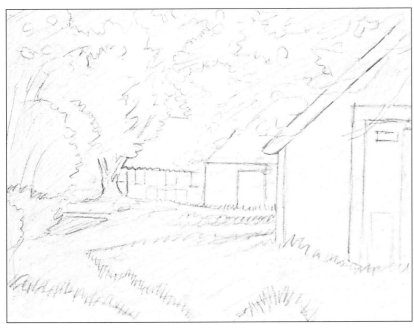

Step 2 Now transform the light, straight lines into more specific shapes and details. Using a softer 2B pencil, darken the contour lines and apply a flat tone over the entire composition, except for the light areas in the sky and the roof of the background building.

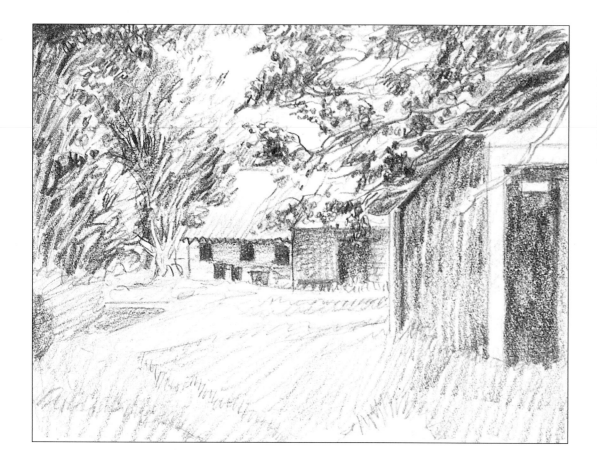

Step 3 To set the range of your value scale, use a 4B pencil to darken the windows, the shed door, and some of the branches and leaves. This tells you where to place your middle values, as the lights and darks already are established.

Step 4 Continue to darken the meadow and its diagonal lines with crosshatching. Using an underhand shading stroke in the trees, darken the largest areas with blending strokes. This brings out the light, which you can further accentuate with a kneaded eraser.

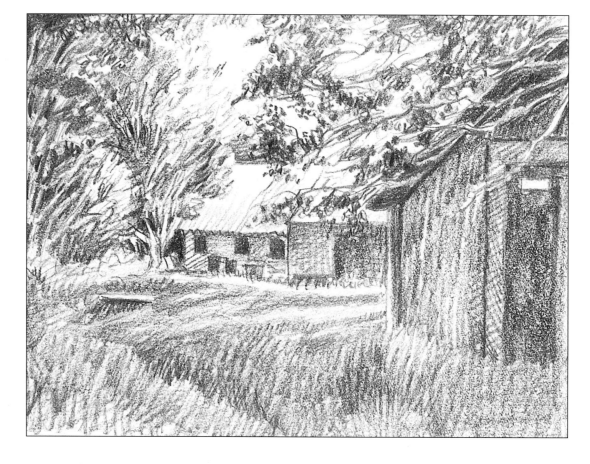

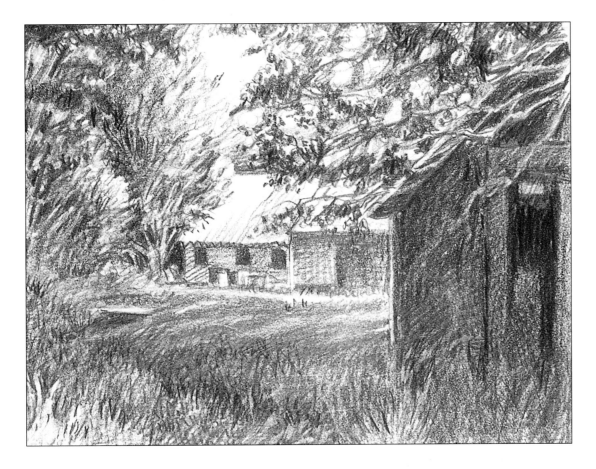

Step 5 To complete the rendering, bring out the lighter and darker values to emphasize the focal point and imbue it with an intimate, inviting atmosphere. Note how the detailed textures and dark values in the foreground push the lighter distant structures into the background. This is an example of aerial perspective.

Contrasting Textures This is a sampling of the various strokes to use to build textural interest in this drawing: On the left and right sides, darken around light areas and then blend over parts to make branches (A). Light cross-hatching on the distant building (B) and heavier crosshatching on the middle structure (C) enhance the perspective in the rendering. Employ medium lines (D), long lines (E), and grassy texture (F) to lend interest to the foreground vegetation. Dark, blended strokes (G) and dots (H) work well for the trees in the background. For the near shed, use dark crosshatching (I) and heavy dark strokes (J). See "Basic Strokes" on page 16 for additional textures.

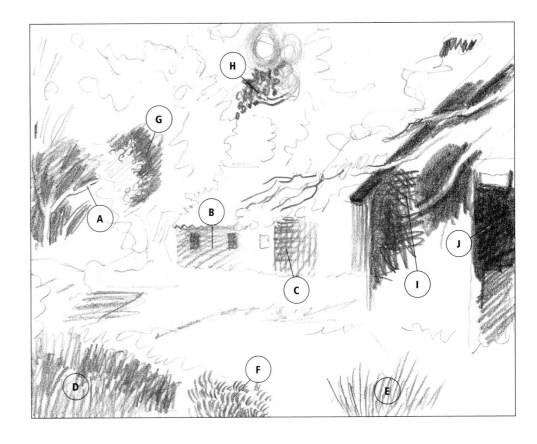

EMPLOYING AERIAL PERSPECTIVE & SHADOWS

In nature, impurities in the air (such as moisture and dust) block out some rays of sunlight, making objects in the distance appear less distinct than objects in the foreground. This phenomenon is referred to as "aerial perspective," and it creates the illusion of depth. Both aerial perspective and foreground shadows give this drawing dimension.

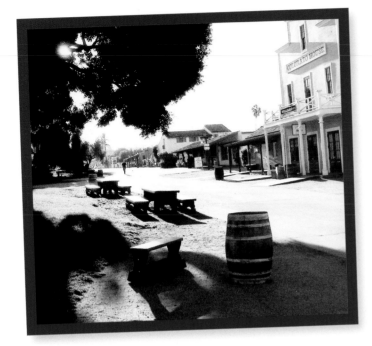

Choosing a Scene This location would be more interesting with long shadows come from the side. Feel free to shift the direction of the shadows by modifying the composition. Despite the limitations of a photo, it can still be a useful reference when building an appealing composition.

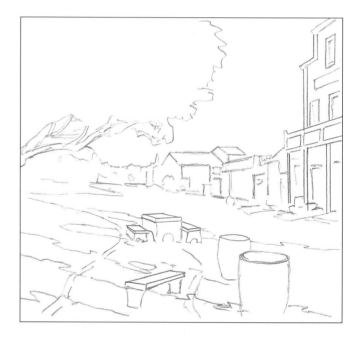

Thumbnail Sketch Draw a thumbnail sketch. After blocking in the basic shapes, lay in the new shadow areas. Lead the viewer's eye into the scene by establishing dark, contrasting shadows across the foreground. This thumbnail is now your value guide; the photo is only a reference for the shapes and details.

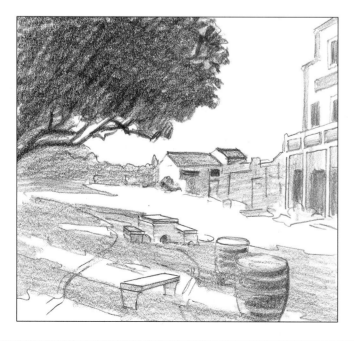

Rough Value Study Shade in the three main values you intend to use: The tree is the darkest value, the shadows and background are middle values, and the rest is light. This is not a final, detailed value study—just a rough guide for you to recognize the light and dark families as you proceed toward the final rendering shown on page 43.

Value Scale I use values 1, 5, and 8 in this drawing.

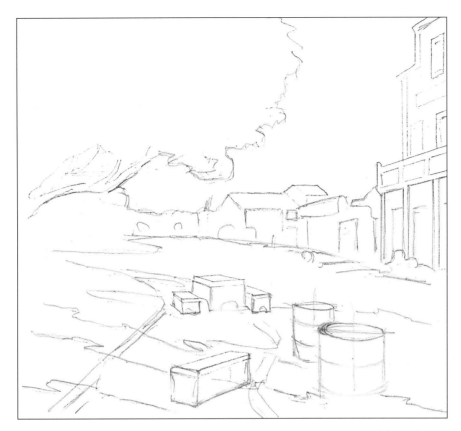

Step 1 Using an HB pencil, lightly block in the general composition, paying special attention to the perspective on the benches, table, and barrels. These shapes, if drawn correctly, will give an indication of the artist's eye level, which is slightly above them.

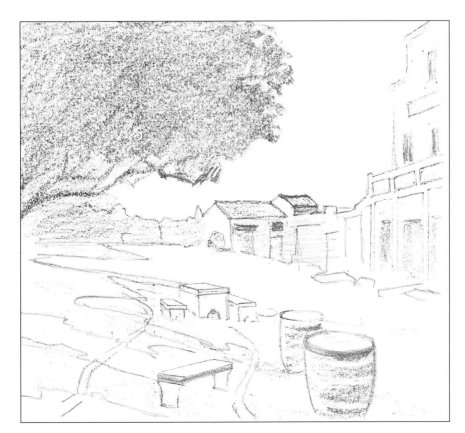

Step 2 Now further refine the shapes and begin to lay in darker values with underhand strokes. Don't get as dark as the value study yet because you still need to be sure that the shapes of the foreground shadows are placed correctly.

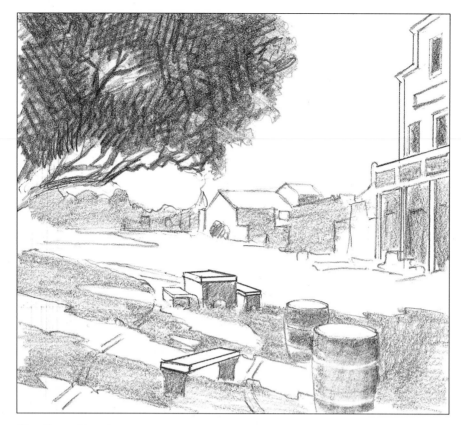

Step 3 Carefully refine the areas of value using softer 2B and 4B pencils. Because the darkest shadows are about as dark as the value study, you can focus on adding textures while maintaining the correct values.

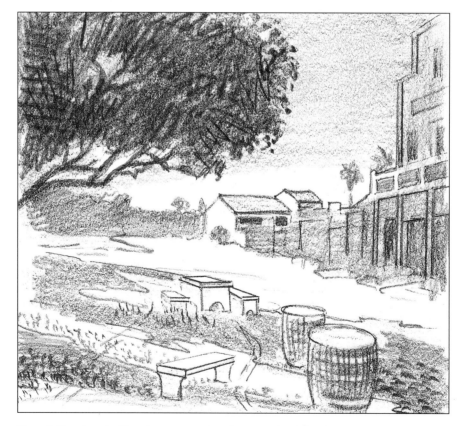

Step 4 Experiment with various textures, but don't completely finish any particular area. Add details such as palm trees in the background, the gradated sky, and the dark windows and doorways.

Adding Textures Here are the strokes to use to finish the drawing: Darken the tree with 4B and 6B pencils, combining sidestrokes and cross-hatching (A). For the sky, combine sidestrokes, linear strokes, and some erasing to lift out lighter streaks (B). For the background, use sidestrokes and an eraser (C). For the grassy area in the foreground, use sidestrokes and grassy strokes (D). Darken the barrel with sidestrokes and linear, vertical strokes (E). The dirt is—appropriately—dirt texture (F).

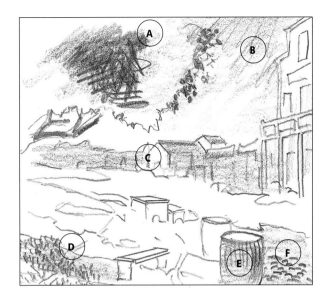

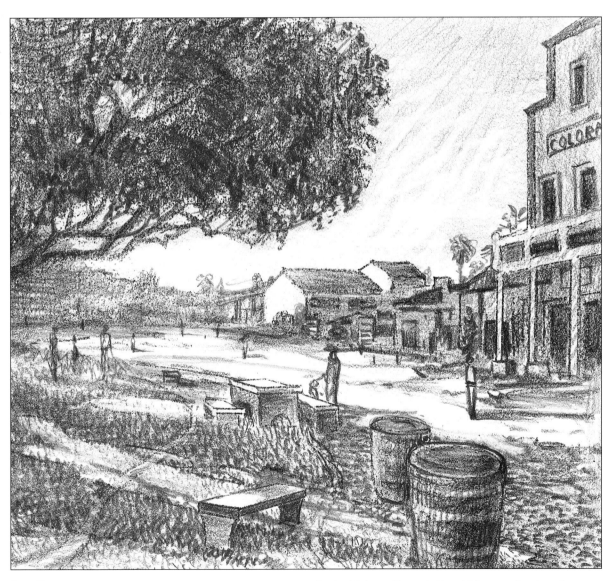

Step 5 Complete the drawing by adding value and texture. Create depth with larger figures in the middle ground and smaller figures in the background, and employ aerial perspective by giving the objects in the foreground the most detail. Darker foreground shadows add to the illusion of depth by contrasting the lighter middle ground and background.

CAPTURING LIGHT ON BLACK-AND-WHITE

As you learned on page 18, a middle value looks darker on white than it does on black. This is the phenomenon of simultaneous contrast. A black-and-white drawing only needs an extra value or two to be added to transform a flat shape into a three-dimensional form. But how does an artist show volume on black? This photograph of a zebra's head offers a perfect opportunity to show how to solve this problem.

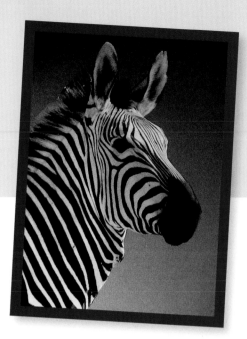

Working with Strong Contrasts This subject presents a challenge in depicting the contrast between black and white without flattening the shape of the zebra's head.

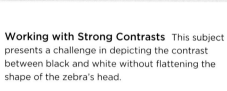

Step 1 Draw lightly with an HB pencil and use straight lines to carefully delineate the top plane, side planes, and anatomical landmarks of the zebra's head. Freely use construction marks to line up the ears, eyes, and nostrils. The underlying blocklike shapes will ultimately determine the values of the black stripes.

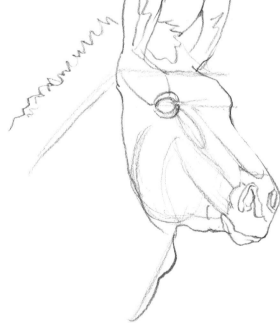

Step 3 Lightly draw additional contours in order to clearly understand which planes and volumes receive lights, middle values, and shadows.

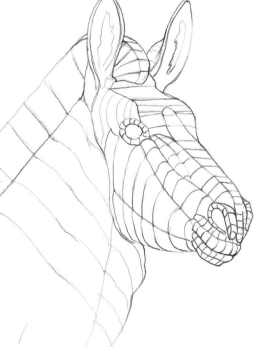

Step 2 Once the proportions are correct, carefully go over the straight lines and transform them into light, accurate, outer contours. Soften and delineate the blocks and cylinders on the head.

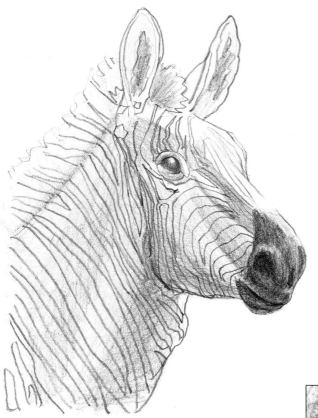

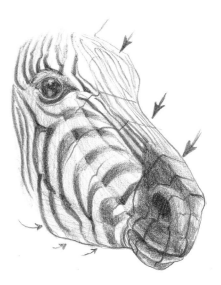

Capturing Variations in Value Study the lines, contours, and arrows in this drawing. A bright source of light bleaches out the dark stripes that face upward toward the light; those same stripes darken in value as they curve away from the light. Also note how reflected light bounces back up to the underside of the head. By capturing these variations in value, you convey the underlying form of your subject.

Step 4 Outline the stripes; then subtly shade the planes and cylinders you established in steps 2 and 3.

TIP

If you find the stripes too complicated to freehand, make a copy of the photo the same size as your drawing paper, and then transfer the stripes from the photo onto tracing paper. Place the tracing paper against a bright window, tape your drawing over it, and trace the stripes.

Step 5 The changing value on the black stripes in this drawing reveals the structure that was rendered with contour lines in step 3 and in the detail drawing (above right). Artists call this principle "local value." As light and shadow hit the forms and the black stripes overlaying them, the black stripes appear lighter or darker. This consistency in change of value reveals form, rather than flattening it.

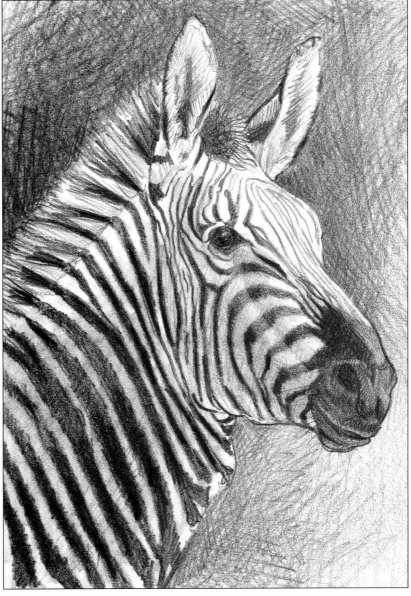

COMBINING THE ELEMENTS OF DESIGN

Line, value, texture, shape, size, and direction are the elements, or main ingredients, of which every drawing is made. As an artist, you must decide how and why each element should be used. On the following pages, you will analyze each element of the seascape below, which makes effective use of each of the elements of design. As you study each individual diagram, compare it with the final rendering on this page to see how each element functions properly in context with the others.

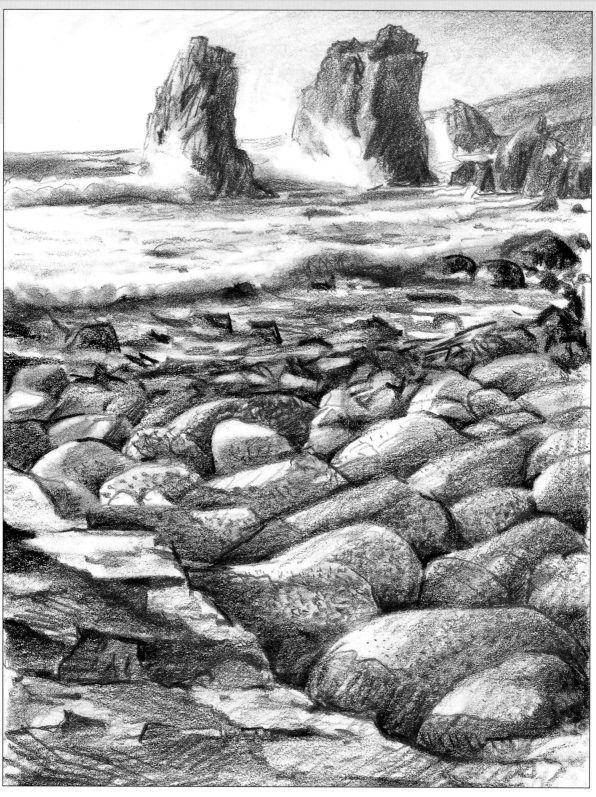

Making Use of Design Elements This seascape makes effective use of each of the elements of design. Over the next three pages, you'll see how each of the elements is used.

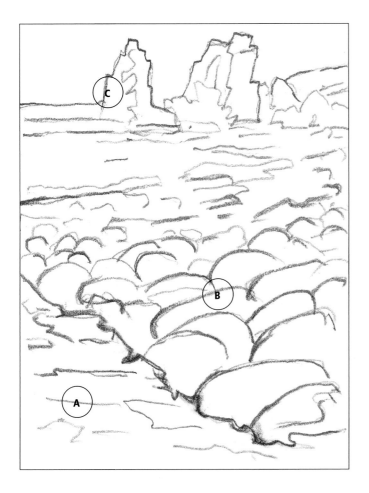

Line You learned on page 19 that lines do not exist in nature; they only exist in the two-dimensional world of drawing. Lines in this seascape are mainly used to separate values of light and dark. In the foreground, a variety of thick and thin lines adds textural complexity and interest (A). The lines around the boulders separate the foreground and background planes (B). The distant rocks use lines to show crevices on the sunlit side (C).

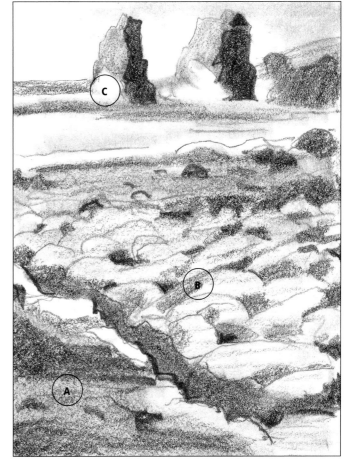

Value Never underestimate the importance of value in drawing. Shapes, lines, and textures hold little interest without variations in value. The distant rocks are the center of interest, so they stand in greatest contrast to the lightest lights (C). The middle-ground boulders are basically middle values with only small accents of light and dark (B). The foreground rocks possess the same value as the more distant boulders, but they are shaped differently to avoid monotony (A).

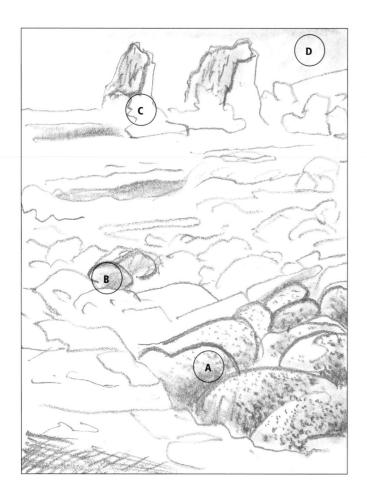

Texture Conveying texture is a challenge because it is an invention of descriptive strokes. Texture is an antidote for monotony but can itself become monotonous if overemphasized. The foreground boulders are granite; small dots show their texture effectively (A). Farther back, the rocks become more atmospheric, and their textures become softer, with fewer dots (B). The distant rocks are a blend of dark softness and small linear markings because they need to stay atmospheric (C). The sky is shaded softly with lights lifted out with an eraser (D).

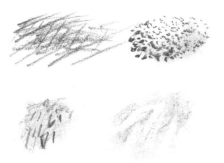

Seascape Textures The textures used for this seascape are shown above. Also see "Basic Strokes" on page 16 for additional textures and strokes.

Shape It is useful to identify shapes as square, round, and triangular, or modifications and combinations of these three basic categories. (See "Understanding Value and Shape" on page 17 for examples of these and other shapes.) None of the shapes in this seascape are clear-cut. The shapes in the foreground are short or long rectangular variations of a square (A). The boulders are round and oval variations of a rectangle (B). The distant rocks in the center are variants of a square (C), and the distant rocks on the right come closer to being triangular (D). Variations in size and value are key in eliminating monotony.

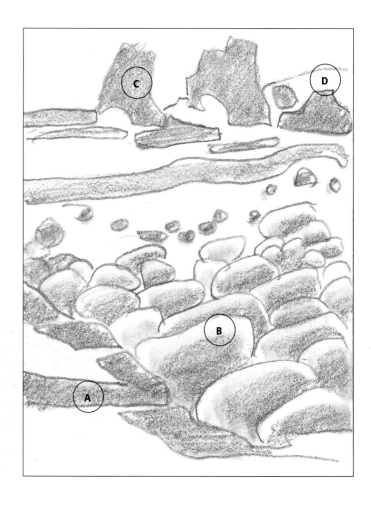

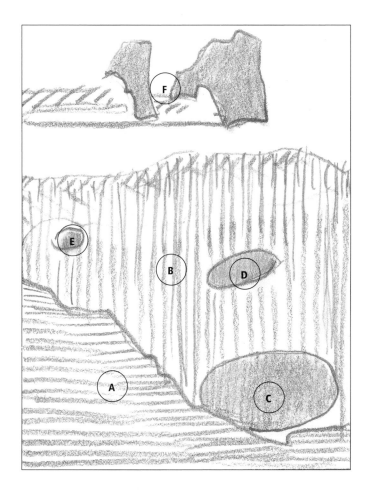

Size In this seascape, size refers to both positive and negative shapes, especially in relation to the contrast between large and small. The eye requires variation to remain engaged, and a successful drawing keeps the viewer engaged. The smaller foreground area (A), with its diagonal, hard, straight edge, sets off the larger, softer area with its rounded boulders (B). The foreground boulders (C), middle-ground boulders (D), and background boulders (E) become progressively smaller, suggesting depth. The distant rocks differ slightly in size against the rectangular negative space (F).

Direction Vertical, diagonal, and horizontal lines all engender emotional responses. A vertical direction expresses austerity and uprightness. Diagonal thrusts imply movement and dynamism. A horizontal line conveys tranquility and repose. All three directions are present in this seascape. Diagonal thrusts provide movement into the picture (B). The diagonal thrust is gently tempered by a counter-diagonal (C) and a horizontal foreground movement (A) that echoes the stable horizon (E). As diagonal thrusts come closer to the horizon, they flatten out and become more passive, as laws of perspective dictate they should (D). Finally, verticals reflect the overall uprightness of the picture itself (F).

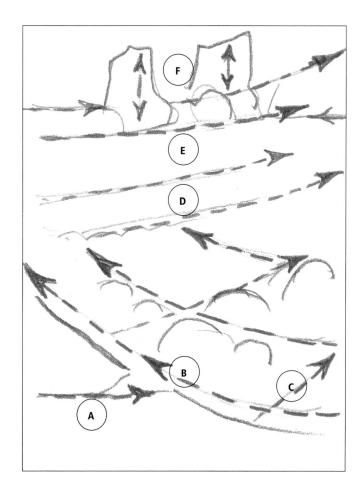

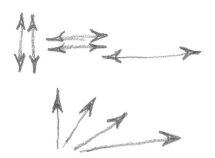

Primary Directions The three main directions of movement are diagonal, horizontal, and vertical.

PULLING IT ALL TOGETHER

This straightforward portrait sums up many of the lessons you've learned. The reminders on the next page are important to keep in mind because they cover the essence of building up any drawing.

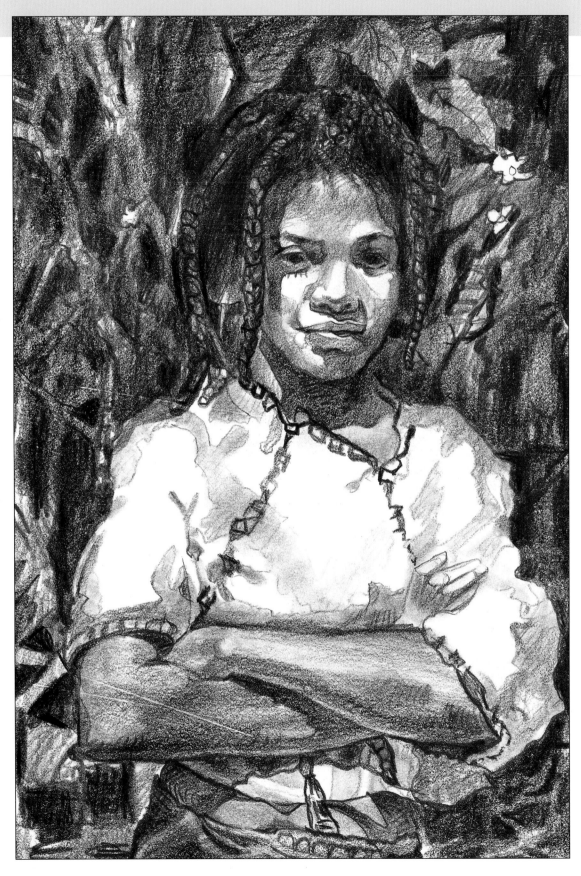

The Sum of Many Parts To create this portrait, first establish the basic values and shapes of the composition. Then add texture and refine the lines, shapes, and values.

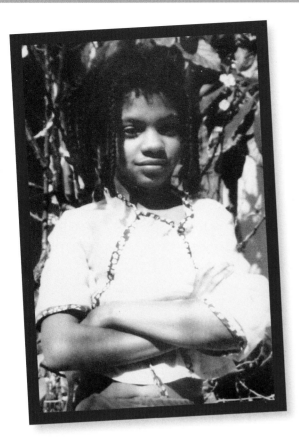

Modifying the Original Image This is a good photo from which to work, but the background is a bit distracting. The solution is to darken and unify the background.

Creating a Thumbnail Value Study When reinterpreting a photo, make small thumbnail drawings. You can still use the photo for details, but the thumbnail value study is your reference map for light and dark values.

Recognizing Positive and Negative Shapes Block out the large shapes before adding details. Most people think concentration means focusing on a specific detail. To artists, it means focusing on the whole first and the parts later.

Refining the Composition With the basic shapes and values worked out, fill in the gradations of line, shape, and value that will give the final rendering depth and dimension.

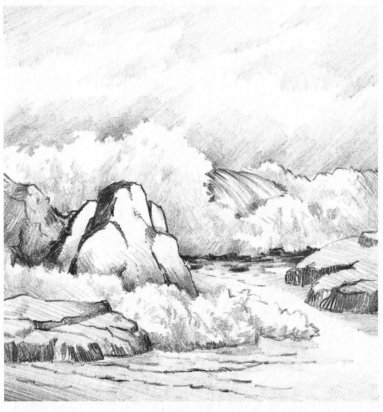

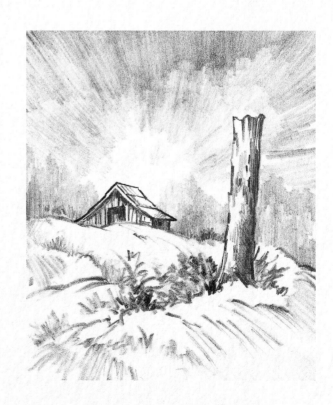

DYNAMIC COMPOSITION

WITH WILLIAM F. POWELL

Creating dynamic compositions involves the careful selection of subject matter and placement of elements within the area on which we have chosen to draw (called the "picture plane"). When we decide to make a drawing, we have to ask ourselves some questions: What should this picture say? What is its purpose? What should be included to make my message clear to the viewer? Often we look at a drawing and feel that something about it is not quite right. Plan your drawings carefully and apply good compositional principles throughout the process, satisfying the viewer's sense of interest, order, and beauty, while providing a rewarding experience for you.

—William F. Powell

CHOOSING A VIEWPOINT

After selecting a subject, consider the viewpoint—the position from which you will observe and portray the subject. The viewpoint incorporates the angle of view (from which direction—right, left, or centered—you observe the subject) and the elevation of view (how high or low your position is when viewing the subject). Your viewpoint must stay the same throughout the entire drawing process.

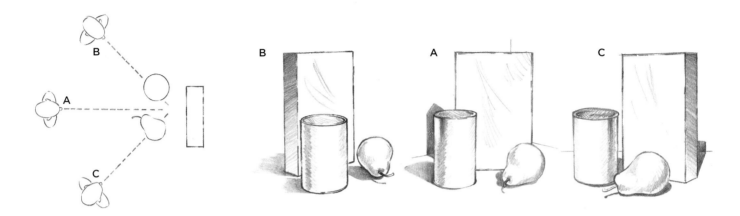

Angle of View When setting up a composition for a drawing, survey your subject from all angles to find the view that will enhance it best. Consider the surrounding elements that you believe will most dynamically highlight the subject. When the artist moves from the A position to B or C, as shown in the diagram above, the composition changes; notice the differences in how all the objects appear and relate to one another. Also observe the change in the composition as a whole. Shifting your angle of view changes virtually everything in the composition.

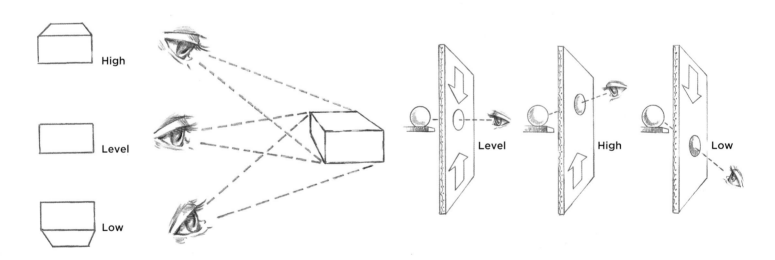

Elevation of View High, level, and low elevation views of the same subject result in very different depictions. From a high angle, the viewer looks down on the object and sees the top and front; in this case, the object's placement on the picture plane is above the horizontal center. In a straight-on view, the viewer sees only the front of the object; its position is at eye level, near the middle of the picture plane. From a low angle of view, the bottom and front of the object is seen; its location on the picture plane is below the center.

SELECTING AN ELEVATION

The choice of elevation of view for a subject greatly affects the composition of a drawing. Experiment with sketching different subjects from various viewpoints. For each composition, decide which elevation portrays your subject in the most harmonious way. Note the differences in the same scene below shown from three elevations: high, level, and low. Elevation can dramatically change any subject: landscape, seascape, still life, or portrait.

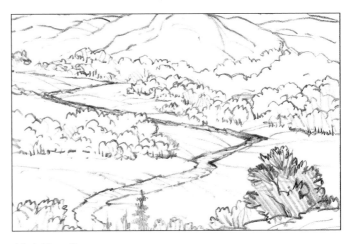

High Elevation

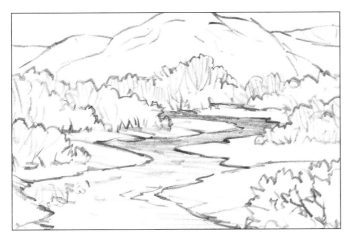

Level Elevation

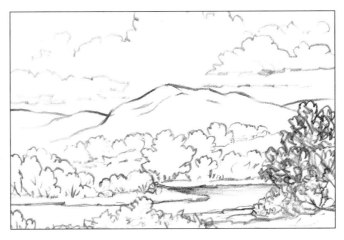

Low Elevation

EXTREME ELEVATIONS

For a dramatic effect, try viewing everyday objects from an extremely high viewpoint—a "bird's-eye" view—or a very low elevation—a "worm's-eye" view. Even common subjects look very important from these exaggerated elevations. Try sketching from extreme elevations using small objects, and see how each changes in shape and presentation.

Bird's-Eye View

Worm's-Eye View

CHOOSING A FORMAT

The two most common formats are vertical (also called "portrait") and horizontal (known as "landscape"), but artists use everything from squares, ovals, and circles to free-form shapes to showcase their drawings. Although some formats are best suited for certain subjects—and vice versa—nearly any format can be used for any subject as long as the drawing is composed correctly. Make simple, small sketches (called "thumbnails") of your subject using different formats; then select the one that makes the best presentation.

Square A portrait of a person can be presented in many formats, but the vertical or square formats are best because they focus the viewer's attention on the details of the face.

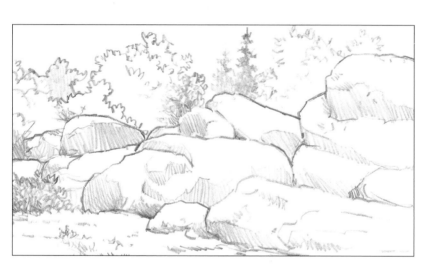

Portrait Although this vertical format is called "portrait," it also is a wonderful shape for presenting cloud scenes and skyscape. Notice the low angle of view with large sky areas and just enough foreground to support the sky.

Landscape A horizontal format provides the width needed for the sweeping panorama of a seascape or landscape. However, it can be just as appropriate for a car, flowers, or any subject if the elements are thoughtfully placed.

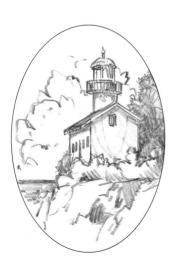

Circle A composition with vertical lines, angles, and opposing lines works well in a circular format, such as this winter scene.

Oval Whether horizontal or vertical, oval compositions immediately draw the viewer's eye to the subject. Each piece of fruit carefully fits within the oval, and all the extraneous sky and land support the lighthouse.

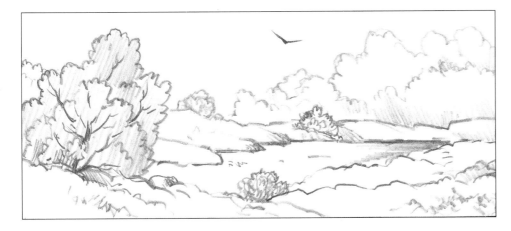

Panorama The bushes on the left side of this panoramic drawing are balanced by the clouds on the right. The bird is slightly off center and acts as a point of interest, bridging the elements on either side and encouraging eye movement.

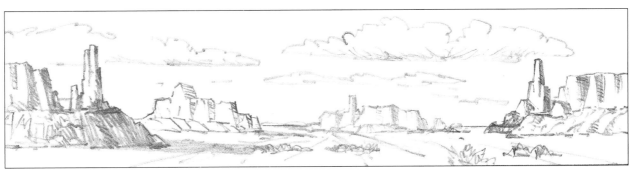

Extreme Horizontal This long, horizontal picture plane allows for a balanced view of the expansive desert. The vastness of the scene spreading across the exaggerated format seems to surround the viewer.

Irregular This sketch of a dog on an organically shaped artist's palette creates an interesting and unexpected presentation, which echoes the shape of the animal's head while reflecting the owner's love of art and the pet.

Extreme Vertical The waterfall has plenty of room to cascade down the tall, narrow picture plane and flow out toward the viewer at the bottom. The surrounding plants and rocks follow the line of the waterfall to heighten the dynamic force of the moving water.

BASIC COMPOSITION METHODS

A successful composition directs the viewer's eye through the drawing, emphasizing the center of interest, or "focal point." Although many factors are involved in creating an effective composition, the way in which you arrange the elements within the drawing is key. Artists use value (lights and darks), depth (the illusion of distance or a three-dimensional quality), and line (the direction or path the eye follows) to create a natural movement and flow of the elements. There are several basic techniques you can use to achieve an interesting composition.

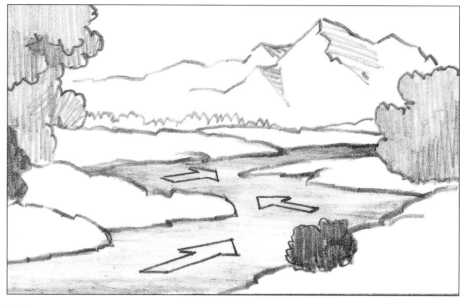

S Shape This composition uses a flattened S shape in the river (see arrows) and is balanced by the large tree mass and the distant mountain and the smaller foliage at the right.

Repetition In this example, one type of flower is repeated in different sizes, strategically overlapped to create the composition. The repetition produces smooth eye flow and rhythmic movement throughout the picture.

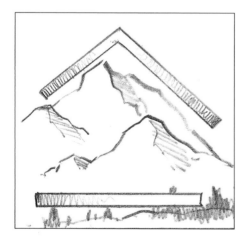

Contrasting Angles and Lines This sketch shows the use of the dramatic, rugged angles of the mountains in contrast with the long, horizontal lines of the ground.

Three-Spot Design This common design places three elements in a picture plane in a triangular arrangement to create balance and harmony within the entire scene.

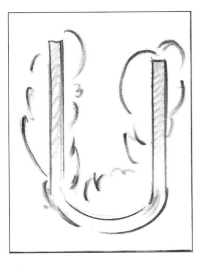

U Shape This shape moves the eye from one side to the other. The U can be distorted by varying the length of the "legs" to achieve a more dynamic effect.

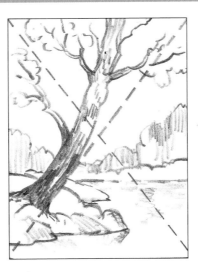

X Shape Here an X shape is the composition guide for a dramatic scene in which the tree almost seems to be falling.

Curved Forms Curved lines are soft and calming. Diagonal and horizontal lines in the middle ground support and contrast the curved forms, adding interest.

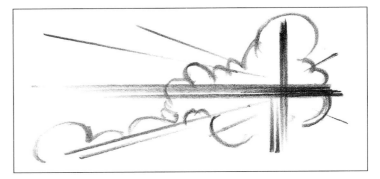

Cross Shape The use of a cross shape draws the viewer's attention to the point where the cross members meet.

O Shape To draw the viewer's eye to the center of a composition, place elements around the area in an O shape.

Opposition The sketch on the left uses opposing lines to focus on a point. In the center, a fluid up-and-down movement is achieved by using curved lines to direct the eye. The intersecting lines on the right are formed by the open ground and the tree; the elements on the opposite side balance the scene.

THE GOLDEN MEAN

The composition of most classical art is based on the Golden Mean, also known as the Golden Ratio, Golden Section, or the Divine Proportion. The Golden Ratio is found all around us in nature: the structure of seashells, leaf and petal groupings, pinecones, pineapples, and sunflowers, for example. This ratio of 1 to 1.618 is also used by designers and artists in all media because it is commonly accepted as the most aesthetic division. Below you will find how to find the Golden Mean of a line.

Method 1: Calculator

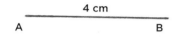

Step 1 Begin by drawing a line of any length and label the two endpoints as A and B. This particular line is 4 cm long.

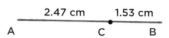

Step 2 Divide the length (4 cm) by 1.618. The number you get (in this case, 2.47 cm) is the distance between A and C above. The line is now divided into two segments of the perfect proportions. You can continue to divide each smaller section of the line by 1.618 to create more divisions in the Golden Mean ratio.

Method 2: Geometry

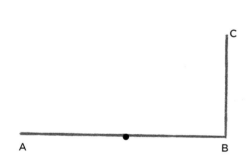

Step 1 Draw a line. Label the endpoints A and B, and mark the center point. Draw a perpendicular line at point B that is equal in length to half of line AB. Label the end point of this new line C.

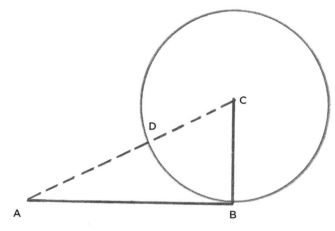

Step 2 Draw a circle with the center at point C and BC as the radius. Then draw a line from A to C. Label the point where line AC passes through the circle as point D.

Step 3 Using point A as the center and AD as the radius, draw a partial circle which intersects line AB; that intersection is at point E (EA = AD). The line is now divided into two segments of the perfect proportions.

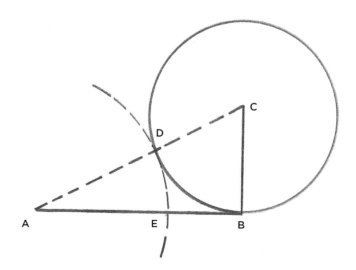

CREATING A GOLDEN MEAN RECTANGLE

The square and the rectangle are two of the most important picture planes for two-dimensional art compositions. Infinite numbers of width and length combinations for these areas exist, but none are more pleasing to the eye and aesthetically proportioned than the Golden Mean rectangle.

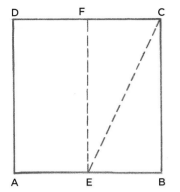

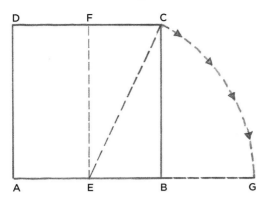

Step 1 Draw a perfect square (ABCD); then draw a vertical center line (EF) through the square. Next draw a line from point E (the halfway mark on the line AB) on a diagonal up to the right corner of the square (C). Set your drawing compass to the length of EC as its radius or measure the length with your ruler.

Step 2 Use the compass or ruler to drop the diagonal line (EC) down until it becomes horizontal, on the same line with A, E, and B. Line EG = EC and BG is the extension length which will create the Golden Mean rectangle. The sides of the rectangle (AD and AG) are in proportion at the 1:1.618 ratio.

Step 3 Draw lines to complete the rectangle, from B to G, G to H, and C to H.

CREATING A GOLDEN MEAN SPIRAL

The Golden Mean rectangle above can be further divided, and a natural spiral can be created within it, using curves drawn on the radius of the square within the rectangle. If you rotate your paper ¼ turn counterclockwise each time you draw a curve, you easily can see where to work next.

Step 1 Erase the extra lines on the Golden Mean rectangle you just created but not the side of the square (BC). Next, draw a 1/4-circle curve in the square with the length of the side as its radius and positioned as shown above.

Step 2 Divide the smaller portion of the rectangle (on the right) into another Golden Mean proportion, drawing a square within it using the length of the shorter side of the rectangle as the length of the sides of the square. Continue the curve as shown.

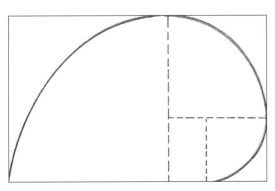

Step 3 Divide the smaller portion of that rectangle into another Golden Mean proportion. Draw a second square using the shorter side of the rectangle as the length for the sides of the square. Continue the curve with the new radius, as shown.

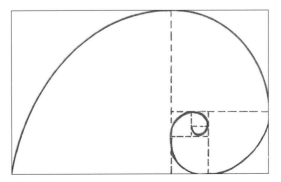

Step 4 Continue dividing each smaller rectangular proportion and drawing the gentle curve in the square as before. This progression can be repeated until you have reached the immediate center point from which the curve originates, if desired.

DIVIDING THE PICTURE PLANE

In addition to the Golden Mean, many other methods can be used to divide the picture plane into a pleasing and balanced composition. The rule of thirds, for instance, is accomplished by drawing lines that divide the picture plane into thirds, both vertically and horizontally, to form a grid that is used as a guide for placing elements. Other methods of dividing the plane use diagonals and right angles. All of the examples are shown using a Golden Mean rectangle as the picture plane, but they also can be applied to other formats.

Basic Rule of Thirds
This diagram shows the basic rule-of-thirds division and object placement.

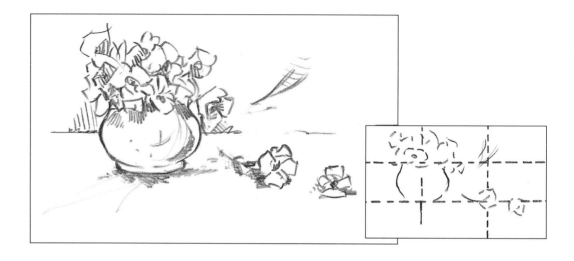

Thirds with One Diagonal
Here the rule of thirds is used with a diagonal. Grid lines divide the plane into three equal parts, vertically and horizontally.

Thirds with Two Diagonals
Draw a diagonal line from one corner to the other. Then add diagonal lines at 90° to the corners. Then place horizontal and vertical grid lines at the intersections of the lines. This forms a grid of thirds with a larger central area and also creates pathways for placing elements.

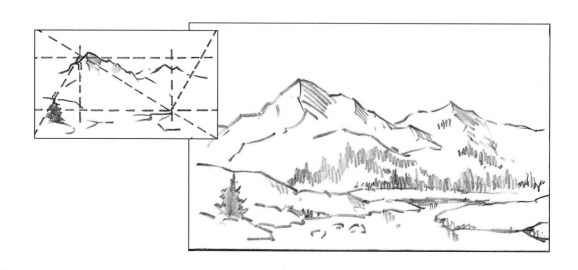

Horizontal Division This scene is divided into three major parts: background, middle ground, and foreground. Elements in each of those areas—the birds, waves, foam, and rocks—contrast the primarily horizontal orientation of the scene.

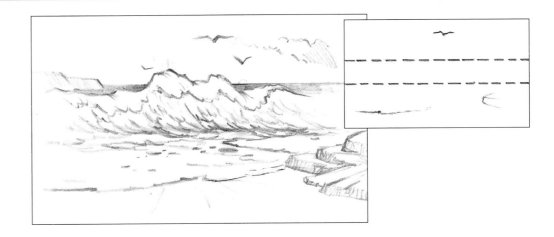

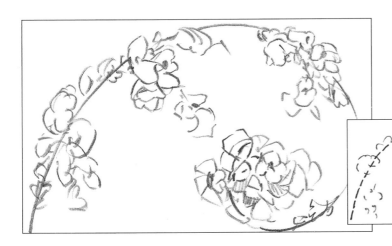

Golden Mean Spiral The spiral created in a Golden Mean rectangle (see page 61) is a wonderful guide for graceful floral designs and even landscapes. You can rotate the spiral on the picture plane, reduce its size, use only a portion it, or combine a spiral with one of the other division methods.

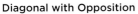

Diagonal with Opposition Draw a diagonal line across the picture plane; then draw a line at 90° to the diagonal extending to a corner. Place the focal point where the two lines meet.

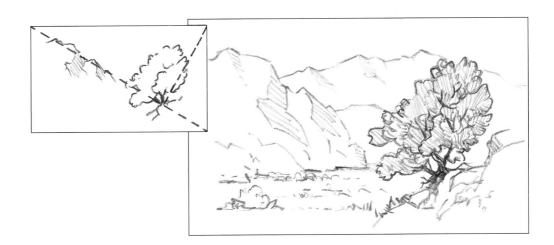

Off-Center Division To place elements just slightly off-center, draw a vertical line in the area where you think the primary subject should be placed (avoiding the center of the paper). Then draw a diagonal line from corner to corner. Add a horizontal line where the first two lines cross. This line is a perfect guide for placing secondary elements.

SYMMETRY AND ASYMMETRY

Symmetry is the balanced similarity of form on either side of a dividing line. Asymmetry is the lack of symmetry. Generally, asymmetry in compositions is more interesting than symmetry, which can be monotonous and fail to capture the viewer's interest. A combination of symmetry and asymmetry makes a composition compelling to the viewer.

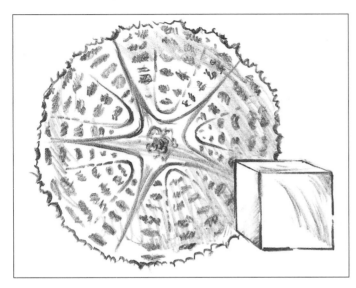

Radial Symmetry A sea urchin has five sets of plates arranged symmetrically around an axis at the base. A salt crystal is an example of three-dimensional symmetry with all the surfaces equidistant from the center.

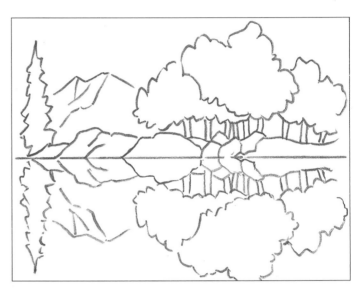

Mirror Symmetry A landscape scene can be "mirrored" or repeated upside down in still water. If there were movement on the water's surface, the reflection would be distorted and the composition less symmetrical.

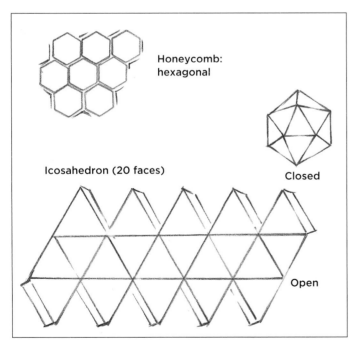

Geometrical Symmetry A honeycomb has a naturally precise hexagonal pattern of repeating symmetry. An icosahedron has 20 symmetrical triangular faces.

Non-Geometrical Symmetry Natural elements, although not absolutely symmetrical, suggest symmetry through repetition of shape and line and balance of weight.

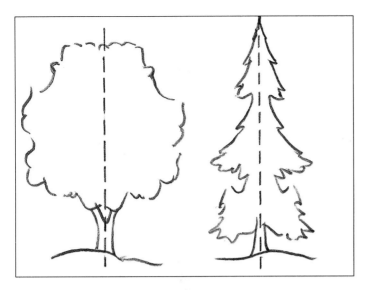

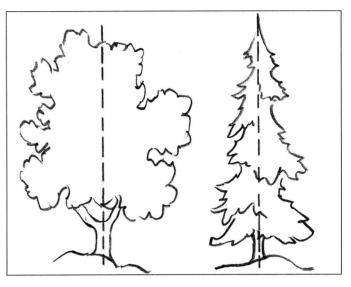

Bilateral Symmetry These trees are exactly alike on both sides of the dividing line. Such shapes rarely occur in nature and present an unnatural look within a landscape composition.

Bilateral Asymmetry Here are the same two trees drawn with slightly different sides. This asymmetry makes the trees appear more natural and appealing.

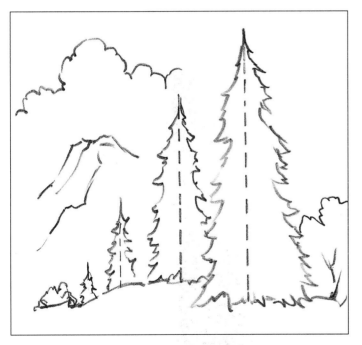

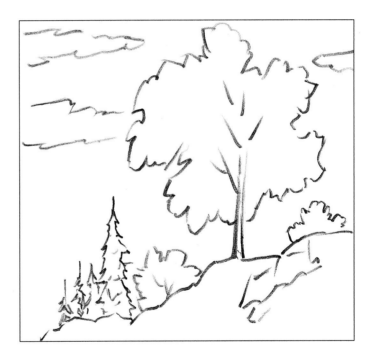

Symmetrical Placement The basically symmetrical form and placement of the pine trees is dominant, balanced by the asymmetrical shapes of the broadleaf trees, mountain, and clouds. This composition shows the use of "translational symmetry," an element repeated to direct the eye into the distance.

Asymmetrical Placement The rounded asymmetry of the large, broadleaf tree in the foreground on the diagonal horizon line is dominant, balanced by the placement of the pines and the horizontal floating clouds. This composition is based on the "Contrasting Angles and Lines" method (see 58).

USING VALUES

As you learned in Chapter 1, values are the light to dark shadings that give a composition a lifelike depiction of depth. The viewer's eye is naturally drawn to areas of great contrast between values—where the darkest darks meet the lightest lights. Artists intentionally use values to direct the viewer's eye and to set the mood of a composition. The three drawings here illustrate different ways you can use value as a compositional element.

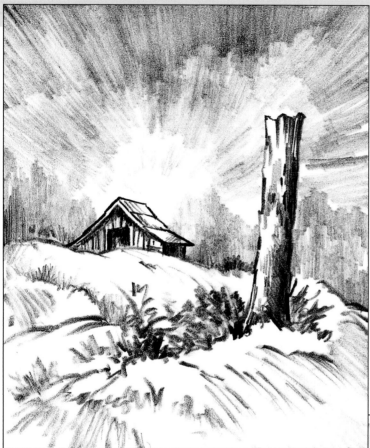

Directional Value Rendering The values in this sunset sky range from the bright highlight of the setting sun to the dark sky behind the clouds. The background values of the sky are made with radiating strokes that seem to converge at one point in the middle ground, and all foreground shading and lines lead to the center of the composition for emphasis.

Minimal Use of Values This scene uses dark values to make the leafless tree the focal point of the composition; other elements are in a narrow range of light to middle values, so they don't draw attention away from the tree.

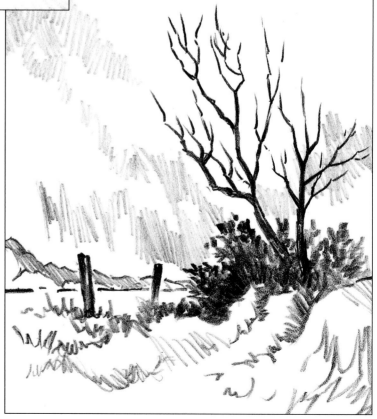

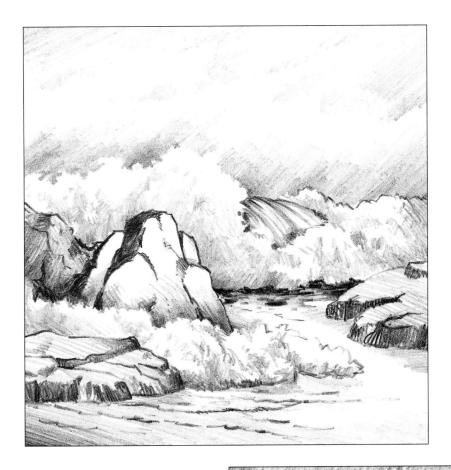

Maximum Value Range
The middle ground of this composition shows the greatest range of values. The lightest values emphasize the most important elements; the light areas are contrasted with adjacent dark shading to draw the viewer's attention to these elements. Note how the diagonal shading of the sky balances the opposite action of the waves and movement of the water.

Value Sketch To render a drawing with a wide range of values, begin by developing a small value-pattern sketch, which shows the main subjects and preliminary shading. As you see the areas develop in the sketch, you can move, lighten, or darken values to enhance the statement of the work. Then use this sketch as a guide for the final drawing.

CREATING A FOCAL POINT

A key element in creating a successful composition is including more than one area of interest, without generating confusion about the subject of the drawing. Compositions are often based on one large object, which is balanced by the grouping, placement, and values of smaller objects. Directing the viewer's eye with secondary focal points helps move the viewer through a scene, so that it can be enjoyed in its entirety.

PRIMARY, SECONDARY, AND DISTANT FOCAL POINTS

The primary focal point should immediately capture the viewer's attention through size, line quality, value, placement on the picture plane, and the proximity of other points of interest which call attention to it. The secondary focal point is the area that the eye naturally moves to after seeing the primary focal point; usually this element is a smaller object or objects with less detail. Another secondary focal point may be at some distance from the viewer's eye, appearing much smaller and showing only minor detailing, so that it occupies a much less important space in the drawing. This distant focal point serves to give the viewer's eye another stop on the journey around the composition before returning to the primary focal point.

From Point to Point The size and detail on the pelican designates it as the primary focal point, and it immediately catches the viewer's eye. The pelican's gaze and the point of its bill shifts the attention to the small birds in the foreground (the secondary focal point). This leads the viewer's eye to another, more distant focal point—the lighthouse. Here the two subtle rays of light against the shaded background suggest a visual path, bringing the viewer's eye back to the pelican, and the visual journey begins again.

Lack of Focal Point When all lines in a composition are drawn with the same depth of intensity (value) and width, the entire design appears flat and uninteresting, with no focal point.

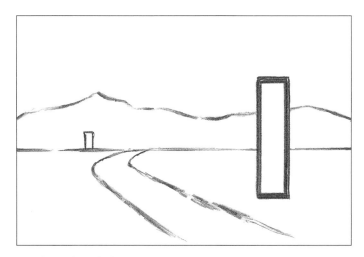

Focal Depth and Flow By simply changing the weight of the lines of the foreground rectangle, and by varying the quality of lines in the road and mountain, the scene has more focal interest.

Focal Curve A graceful curve leads the eye into the composition.

Focal Depth The focal curve is one way of creating depth in a composition; here it serves as a road in a natural setting.

Multiple Focal Curves To further accentuate the feeling of distance, use more than one curve, along with multiple elevation lines.

Sketching Focal Patterns While creating a preliminary sketch, look for the focal pattern—how the eye moves around the picture and what is important—and adjust as needed.

Develop the Pattern Now lightly add details to build the feeling of rhythmic movement and depth. Vary line weights and refine the shapes of the elements. Use value to further accentuate the focal pattern.

FORMING & PLACING ELEMENTS

The basic shapes used in creating visual art—the square, rectangle, circle, and triangle—are two-dimensional (2-D). The diagrams below show how to create the illusion of depth (three dimensions or 3-D) by extending each 2-D shape. When drawing, you will combine and modify these 3-D forms to create the elements in your composition. For an effective composition, overlap these 3-D forms on the picture plane to unify the elements and provide depth. At the same time, make sure the arrangement displays a balance in which the elements' size, placement, and value occupy the space to create a harmonious composition.

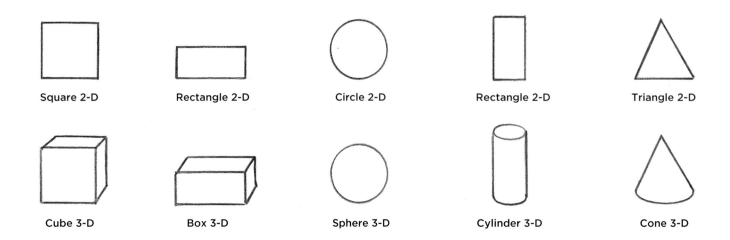

Square 2-D	Rectangle 2-D	Circle 2-D	Rectangle 2-D	Triangle 2-D
Cube 3-D	Box 3-D	Sphere 3-D	Cylinder 3-D	Cone 3-D

ARRANGING ELEMENTS IN A STILL LIFE

Turning Shape into Form You can see these forms, all derived from basic shapes, in many still life compositions. Cut a sphere in half for a bowl. A circle can become an orange; a cylinder, a can. Stretch a circle horizontally to create a lemonlike ellipse.

Monotonous Composition Elements in a continuous line creates a monotonous and boring composition. There is a slight sense of depth achieved by overlapping, but all the attention is focused on the last item, the vertical can.

No Depth or Balance This C-shaped composition offers a slightly better placement, but when elements are just touching—not overlapping—nothing creates depth or balance.

Pleasing Composition Here some elements overlap—the orange sits in the bowl for further interest. The elements balance one another and hold the viewer's interest.

One Dominant Element This arrangement is fairly comfortable, even though the cylinder is quite dominant. If you wish to emphasize one major element, be sure that it is worthy of the attention and that the other elements support it. Overlapping the objects creates depth and supports the cylinder.

Unbalanced Placement This composition leaves the viewer with the feeling that everything is falling off the page. In addition, the side of the cylinder is at the center of the bowl, visually cutting the composition in half.

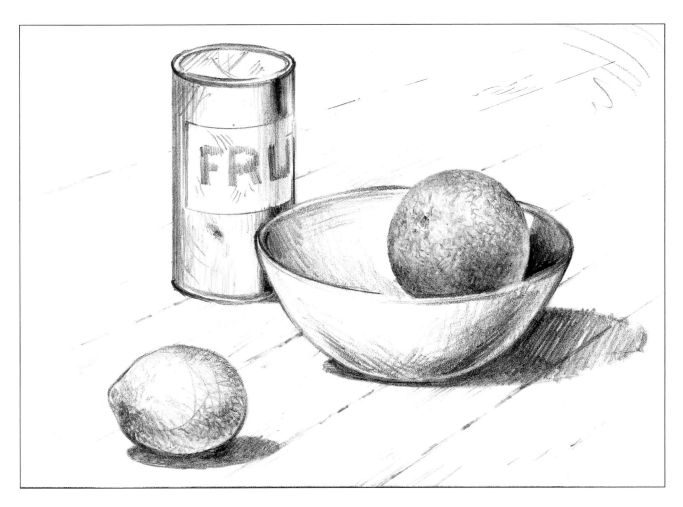

Placing Still Life Elements This finished sketch uses the "Pleasing Composition" thumbnail as a guide. With shadows, textures, and a surface (the wooden table), the finished composition shows depth and dimension.

ARRANGING A FLORAL COMPOSITION

Few drawing subjects require more intensive composition than a floral arrangement, which is a work of art in its own right. Carefully consider balance, line, value, and form, and limit the number of flowers so each can be seen and appreciated. Avoid arranging the flowers so that they visually "pair up," as this stops the viewer's eye. For that reason, try grouping the flowers in odd numbers or arrange them so that they form a triangle. Also be sure to limit the amount of greenery to allow the flowers to be the primary focal point, choose a complementary container to hold the flowers, and carefully consider the drapery beneath and behind the floral arrangement.

Step 1 Block in the magnolias and large leaves to form a triangle, which mirrors the cone-shaped top of the vase.

Step 3 Begin shading and concentrate on value changes in each segment as shapes overlap to create depth.

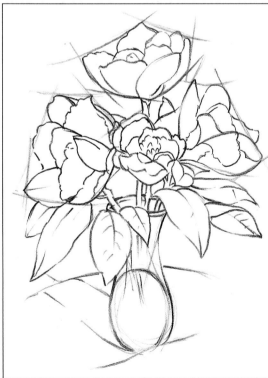

Step 2 Refine the lines, letting the curve of the leaves lead the eye down to the vase and then up the stems to the flowers.

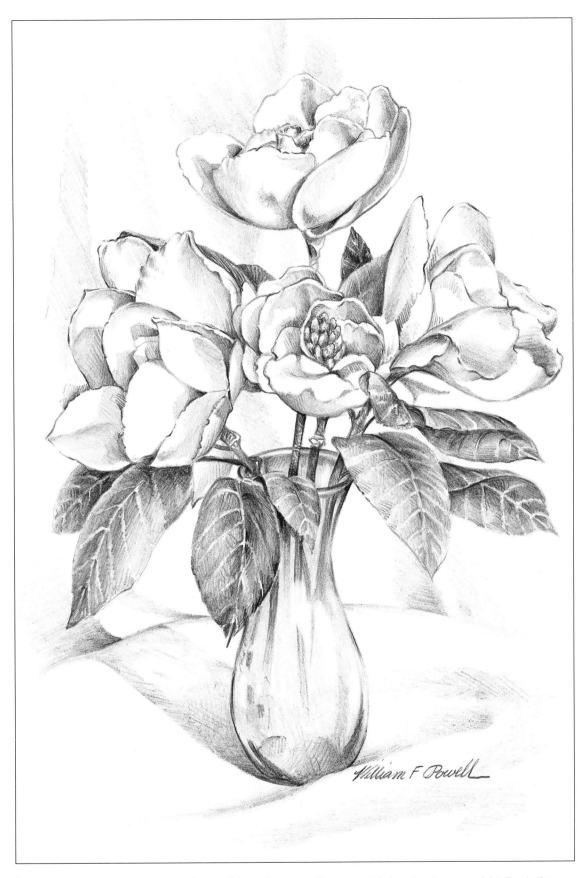

Step 4 Continue shading the individual parts of the entire composition, using delicate value changes and detailing in the flowers, leaves, and vase. Add the background and tablecloth, using cast shadows and the values in the folds to enhance the composition.

PLACING PEOPLE IN A COMPOSITION

The positioning and size of a person on the picture plane is of utmost importance to the composition. Practice drawing thumbnail sketches of people to study the importance of size and positioning.

CREATING BALANCE

Because the eyes catch the viewer's attention first, place them above the center line. Avoid drawing too near the sides, top, or bottom of the picture plane, as this gives an uneasy feeling of imbalance. The open or "negative" space around the portrait subject generally should be larger than the area occupied by the subject, providing a sort of personal space surrounding them.

Placement of a Portrait The smaller thumbnails here show the girl's head placed too far to the side and too low in the picture plane, suggesting that she might "slide off" the page. The larger sketch shows the face at a comfortable and balanced horizontal and vertical position.

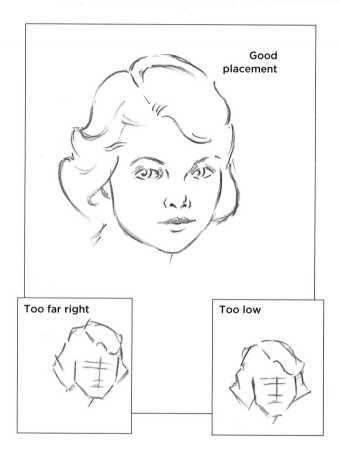

Good placement

Too far right

Too low

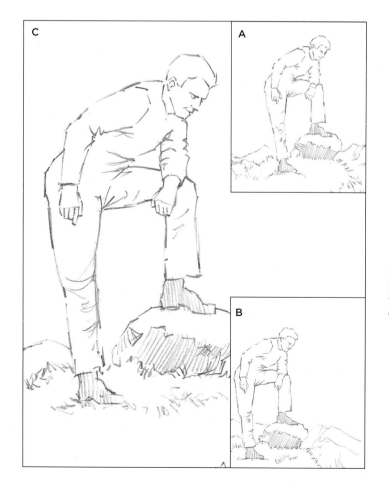

Full Figure Placement In thumbnail A, the subject is too perfectly centered in the picture plane. In thumbnail B, the figure is placed too far to the left. Thumbnail C is an example of effective placement of a human figure in a composition.

DRAWING MULTIPLE SUBJECTS

If you are drawing several, similarly sized subjects, use the rules of perspective to determine relative size. See the diagrams below for drawing proportional faces and full figures.

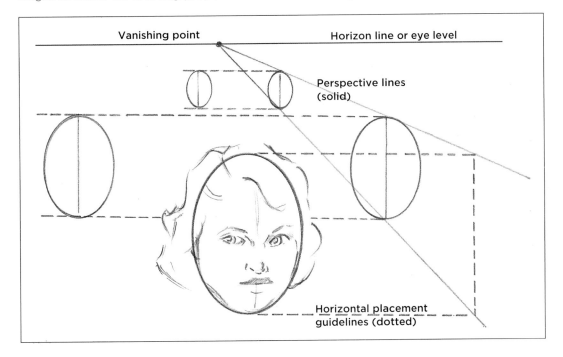

Proportional Faces Draw a vanishing point on a horizon line and a pair of perspective lines. Receding guidelines extended from the perspective lines will indicate the top of the head and chin of faces throughout the composition. The heads become smaller as they get farther from the viewer.

Sizing Multiple Figures Start by drawing a horizon line and placing a vanishing point on it. Then draw the main character (on the right here) to which all others will be proportional. Add light perspective lines from the top and bottom of the figure to the vanishing point to determine the height of other figures. To draw figures on the other side of the vanishing point, add horizontal placement guidelines from the perspective lines, and then add perspective lines on that side.

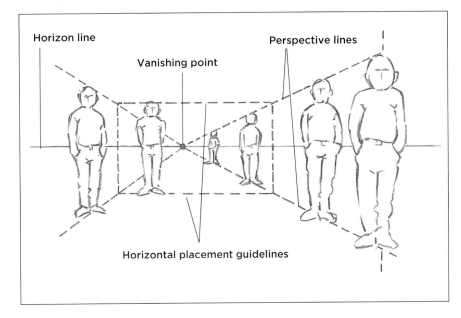

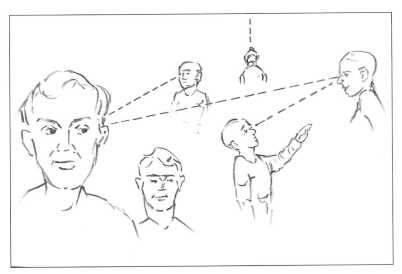

Line of Sight Figures in a composition can relate to each other or to objects within the scene through line of sight (shown here as dotted lines). Show line of sight with the eyes, head position, or even a pointing hand. The viewer's eye follows these indications and is guided around the picture plane.

COMPOSING LANDSCAPES

When composing a landscape, consider the elements you want to include and adjust their size, placement, values, and lines to create a pleasing and balanced composition. The following examples show the relationship of basic elements to one another and to the picture plane in a landscape. The lines could represent trees, buildings, flowers, or other elements in a composition.

Too Uniform When objects are all uniform, centered on the picture plane, and absolutely balanced, the composition can be monotonous.

Some Interest Angling the object in the center creates interest, but this design is still too uniform; it doesn't lead the eye through the composition.

Too Much Opposition These elements have balanced placement, but the outward angle of the side elements gives an unsettling feeling.

Unsteadiness Although this arrangement is secure and balanced, it still imparts a feeling of unsteadiness. Less severe angles might help.

Unbalanced The tree is not balanced by any other object on the picture plane, which makes it seem uninteresting and isolated.

Overpowering The tree overwhelms the picture plane, dividing it in half. There's no-where for the viewer's eye to move.

Uncomfortable The tree is the sole focus. It is too far forward and too far to the left for a balanced placement.

Comfortable The tree at right is partially out of the picture plane. Its leaves lead the viewer's eye to the small tree.

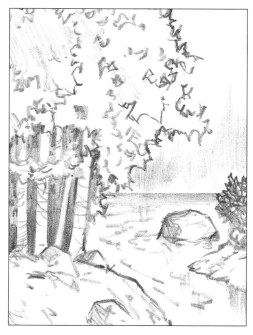

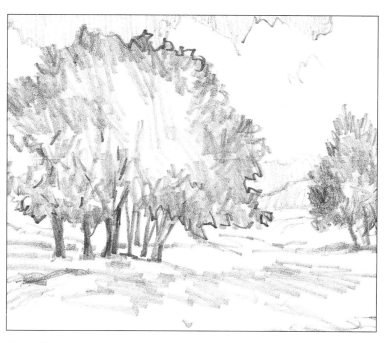

Balanced Mass The foreground trees are balanced by the rock, land, and bush to the right, with the lake and background trees for support.

Repetition for Unity The shape of the stand of trees on the left repeats on the right in the more distant grouping. The curve of the clouds echoes the tree shapes and hills, which also helps to unify the composition.

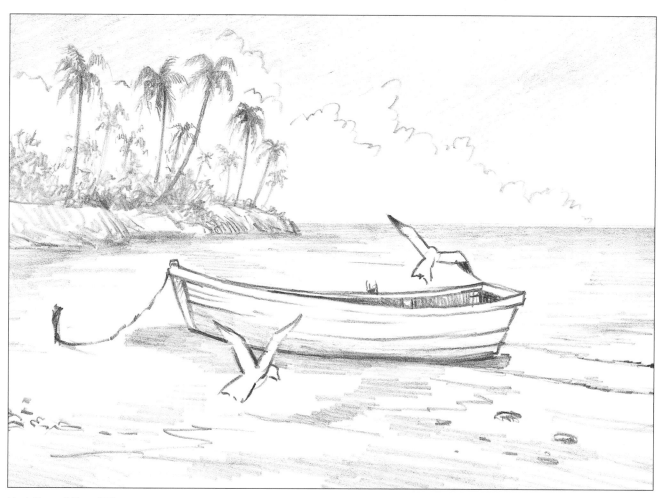

Variation of Focal Element Draw the scene above, substituting each of the boats shown below. Changing the focal element will alter the composition dramatically, leading the eye to different areas of the drawing.

USING NEGATIVE SPACE

Negative space is the area of a composition that is around or between the focal elements. Often this negative space is as important to the composition as the focal elements, providing balance and unity. Observing and drawing the details within the negative space—even before completing the other elements—is an important technique in creating a realistic composition. The negative space supports the focal elements by offering both repetition and contrast in line, values, textures, and shapes to heighten interest in the composition.

Blocking in Negative Spaces In this sketch, everything between the foreground trees is negative space. Use light guidelines to define the large tree trunks. For interest, contrast those strong verticals with the horizontals that form the sky, foliage, and open middle ground to create a pleasing composition. Begin to add the shading within those negative spaces.

Adding Details for a Balanced Composition
Now add details within the negative shapes to give the composition depth, contrast, and balance. By adding the darks to the negative space around the white-barked birch trees, you define the trees' edges. Balance the deeply shaded, heavily textured tree in the foreground with the lighter, smoother area of the sky. Make the foreground grass strokes and details soft to support to the scene without catching the eye and disrupting the carefully balanced composition.

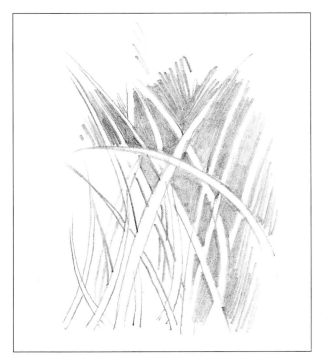

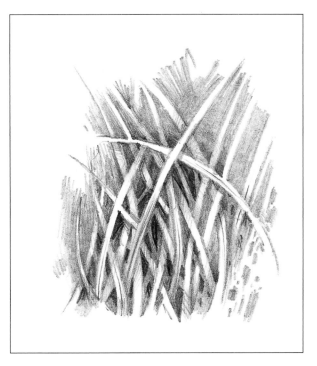

Delineating Contrasts Lightly draw guidelines for some blades of overlapping grass, and then shade the middle values in the negative spaces to define those grasses. This composition repeats the actively opposing elements of the grasses, contrasting them with the rectangular negative spaces.

Developing Complexity and Unity Develop intricacy in the composition by working darker values into the negative spaces, as well as by shading the grasses. The composition becomes more interesting through the negative space, which unifies the grass into one mass.

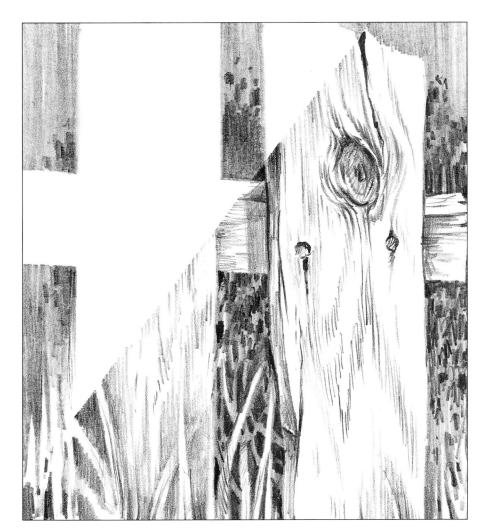

Creating Depth and Repetition
To create the shape of an old wooden fence, draw objects in the negative spaces around it (upper left). Add dark and light value patterns to suggest the distant sky and foliage. Then shade the white boards to create texture and shadows (right). Within the negative space, develop patterns of secondary negative shapes by adding more darks to convey depth (such as the space between blades of grass). The single horizontal board and sky help contrast the mainly vertical elements while offering clear indications of depth.

COMPOSING FROM PHOTOGRAPHS

Photos are great references for creating compositions. Use one photo or take elements from a number of photos and combine them in one composition. One photo can offer several different compositions; just crop the photo in a way that emphasizes the main elements and makes a statement about them. Use your "artistic license" to move or eliminate elements, or to add detail. When composing a scene from a photo, look for the qualities that make a dynamic composition: depth through shadows and overlapping, asymmetrical placement, rhythm and flow, value contrasts, interesting lines and textures, and balance.

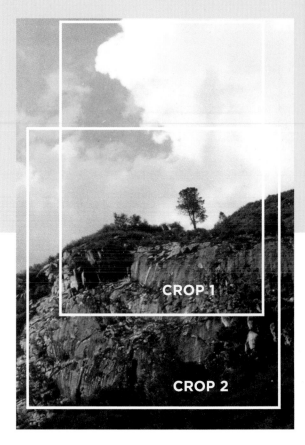

Shifting Focal Points In crop 1 at right, much of the vertical cliff face is cut away; the lone tree is the central focal point, and the clouds and cliff rocks are balanced secondary elements. In crop 2, the cliff face becomes a much stronger element, drawing the eye first, then leading up to the tree.

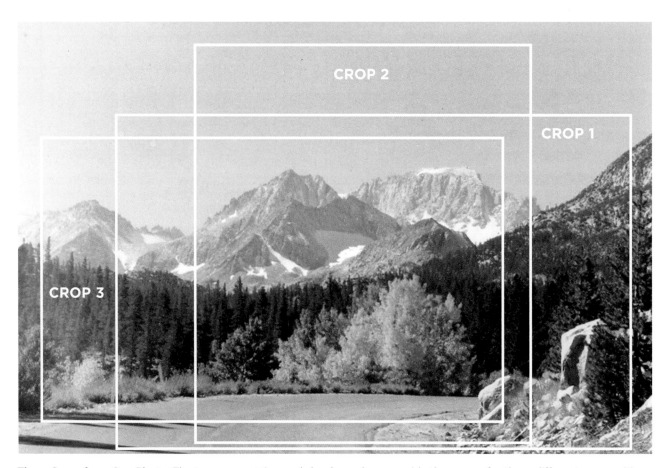

Three Crops from One Photo The trees, mountains, and sky shown here provide the source for three different compositions. Each crop accents an important part of the scene. Lay strips of paper around each crop to isolate it and study the differences.

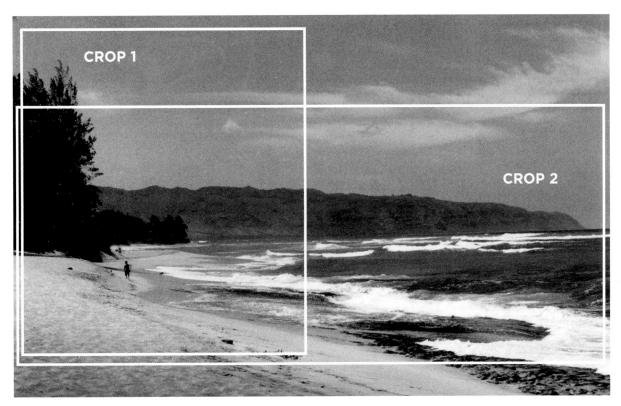

Vertical and Horizontal Crops This beautiful beach scene in Hawaii is an example of how two very different compositions can come from one photo. The vertical crop (1) accents the lone person with the open sky and foreground beach. The horizontal crop (2) accents the long expanse of land and sea and makes the individual on the beach appear much smaller and isolated.

Maximize the Crop This photo, taken on Kauai, shows the mysterious afternoon clouds that float into the canyons. The single crop removes featureless cloud areas and focuses the viewer's eye on the foreground tree against the dramatic cloud formation.

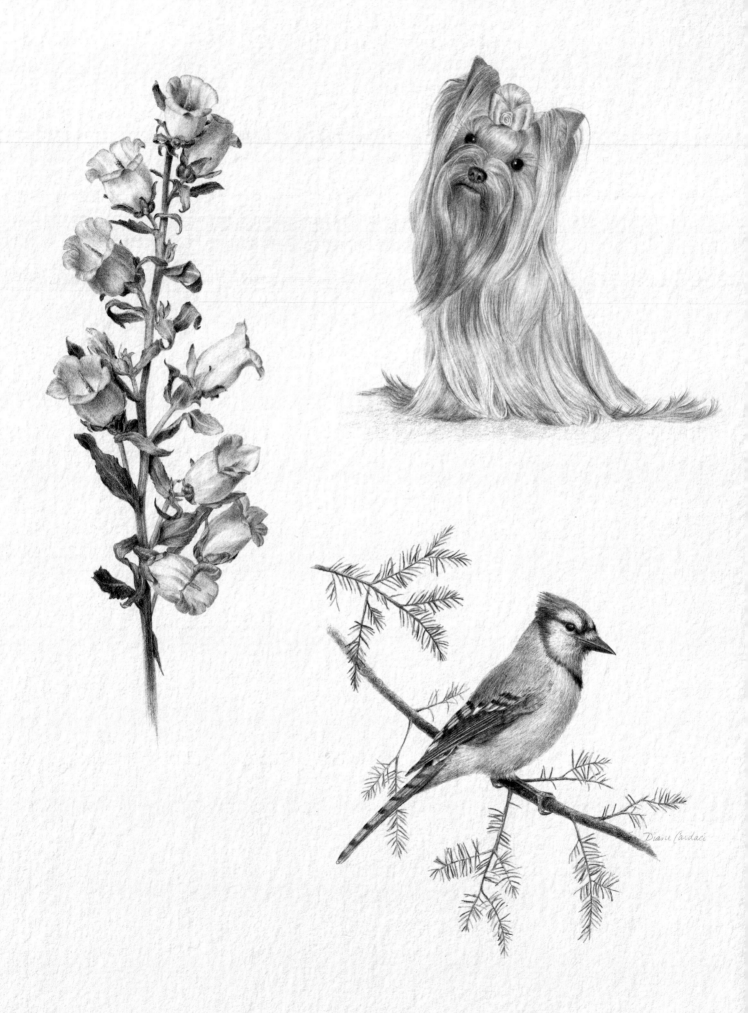

REALISTIC TEXTURES

WITH DIANE CARDACI

Over the years, my continuous fascination with texture has inspired me to use the pencil as a powerful tool of artistic expression. I have learned from teachers and fellow artists, as well as from studying the drawings of the Old Masters. Some of my favorite techniques, however, have come from just taking the time to experiment with hand position, pressure, the grade of the graphite, and different types of papers. This chapter is designed to share some tried-and-true techniques, as well as to inspire you to play with pencil textures. In addition to standard step-by-step lessons, I've also included creative exercises that focus on your artistic nature. Explore the world of textures and see what you can create on your own. See what your pencil is truly capable of and let it become a part of your creative palette. Enjoy!

—Diane Cardaci

"PAINTING" WITH PENCIL

When you use painterly strokes, your drawing will take on a new dimension. Think of your pencil as a brush and allow yourself to put more of your arm into the stroke. To create this effect, hold the pencil between your thumb and forefinger and use the side of the pencil. (See page 6.) If you rotate the pencil in your hand every few strokes, you will not have to sharpen it as frequently. The larger the lead, the wider the stroke will be. The softer the lead, the more painterly an effect you will have. These examples were all made on smooth paper with a 6B pencil, but you can experiment with rough papers for more broken effects.

Starting Simply First experiment with vertical, horizontal, and curved strokes. Keep the strokes close together and begin with heavy pressure. Then lighten the pressure with each stroke.

Varying the Pressure Here randomly cover the area with tone, varying the pressure at different points. Continue to keep your strokes loose.

Using Smaller Strokes Make small circles for the first example. This may remind you of leathery animal skin. For the second example, use short, alternating strokes of heavy and light pressure, similar to a stone or brick pattern.

Loosening Up For grass (at right), use vertical strokes. Vary the pressure for each stroke, and you'll start to see long grass. At the far right, use somewhat looser movements that could be used for water. First create short spiral movements with your arm (above). Then use a wavy movement, varying the pressure (below).

WORKING WITH DIFFERENT TECHNIQUES

The techniques shown below are important for creating more painterly effects in your drawing. Remember that B pencils have soft lead and H pencils have hard lead; you will need to use both for these exercises.

Creating Washes Create a watercolor effect by blending water-soluble pencil shading with a wet brush. Make sure your brush isn't too wet, and use thicker paper, such as vellum board.

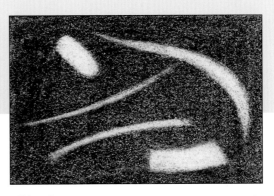

Lifting Out Blend a soft pencil on smooth paper, and then lift out the desired area of graphite with an eraser. You can create highlights and other interesting effects with this technique.

Rubbing Place paper over an object and rub the side of your pencil lead over the paper. The strokes of your pencil will pick up the pattern and replicate it on the paper. Try using a soft pencil on smooth paper, and choose an object with a strong textural pattern. A wire grid was used for this example.

Producing Indented Lines Draw a pattern or design on the paper with a sharp, non-marking object, like a knitting needle or skewer, before drawing with a pencil. When you shade over the area with the side of your pencil, the graphite will not reach the indented areas, leaving white lines.

SMUDGING

Smudging is an important technique for creating shading and gradients. Use a tortillon, blending stump, or chamois cloth to blend your strokes. Do not use your finger because your hand, even if clean, has natural oils that can damage your art.

Smudging on Rough Surfaces
Use a 6B pencil on vellum-finish Bristol board. Make your strokes with the side of the pencil and blend. In this example, the effect is granular.

Smudging on Smooth Surfaces
Use a 4B pencil on plate-finish Bristol board. Stroke with the side of the pencil, and then blend your strokes with a blending stump.

COMBINING TECHNIQUES

Various techniques can be combined to create unique effects. By experimenting with them, you can see how many different effects you can create by just changing your pencil, the amount of pressure you place on the pencil, or your hand position. For example, making an indented line and applying tone over it is a great way to show the fine veins of a leaf. By letting loose, you may come across an accidental technique that is perfect for what you are trying to express.

Crosshatching and Stippling Use the side of a 2B pencil, and quickly stroke back and forth across the paper in a zigzag manner. Next take a sharp HB and create cross-hatched lines on top. Switch to a large lead holder with a 6B lead and use heavy pressure to put some stipple on top. This effect looks like a chain link fence covered by flowers.

Indentations and Water Before making any marks with the pencil, use a knitting needle to make impressions in the paper. Then use the side of a water-soluble pencil to lay down some tone. Next take a wet watercolor brush and smear the graphite. This technique is very useful when you want to create a scratchy, rough look, such as old leather or weathered metal.

Smearing and Lifting Smudging is a great technique for rendering softer textures, such as fur. Use a soft 6B pencil to make some horizontal strokes and then lightly smear them with a blending stump. On top of this, place some very heavy, curved, short strokes. Then use a kneaded eraser to lift out random spots of graphite. This texture is reminiscent of a nubby sweater.

Using Textured Paper and Soft Pencil Here rough paper combined with a soft pencil creates the appearance of rocky dirt. Use a vellum paper and draw with the side of a 6B. Put down heavy tone and dab a few spots with a kneaded eraser, but don't worry much about texture because the paper is creating it for you. Then use a sharp 2B to draw a few individual rocks. This evokes the feeling of a gravelly road without adding much detail.

FOLLOWING FORM

In addition to creating form, light also creates the texture of an object. As the light falls across an object with a strong texture, each individual aspect of the texture will create its own light and shadow effect. But these individual value changes must remain secondary to the form shadows, or the form will be lost. For example, if you draw a very thick texture all over an object and forget to include highlights to show the object's shape, the object will appear to be flat and without depth.

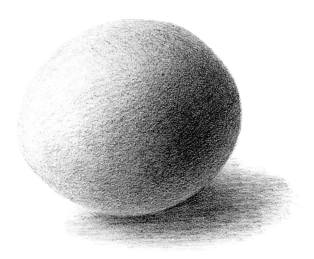

Seeing Form A coconut (shown above as being lit from a three-quarter angle) has a form similar to that of an egg. Imagine the coconut with a smooth, egglike surface. Once you understand the way the light is hitting the object, you can draw its form.

Form vs. Texture A coconut is a good example of texture versus form. You might be tempted to use dark, heavy shading to portray the coconut's surface. However, in this case, the coconut's form is more important than its texture.

Studying Shapes To understand how the light source creates the form of this tree, break down the tree into a ball and a cylinder. Use rough paper to add some texture, and put down a layer of dark tone with the side of the pencil.

Adding Detail Using short strokes, create the leaves. Don't get caught up in drawing individual leaves; instead suggest the leaves with a pattern of texture. Leave the texture lighter on top where the light source hits the top of the tree.

BOTANICAL TEXTURES

Botanical drawings are portraits of plants that are drawn with realism. They show the beauty of flowers and other plants with their intricate and delicate detail. When drawing botanical compositions, remember that plants come in many shapes, sizes, and textures. Besides their general shape, carefully observe their edges (irregular or smooth), shininess (glossy or matte), and thickness.

PARTS OF A FLOWER

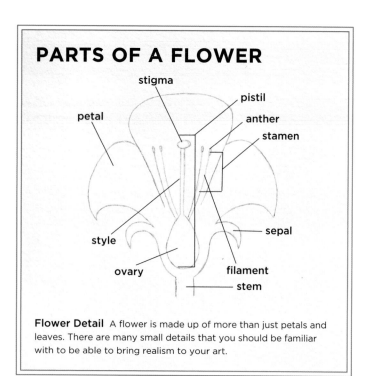

Flower Detail A flower is made up of more than just petals and leaves. There are many small details that you should be familiar with to be able to bring realism to your art.

LEAVES

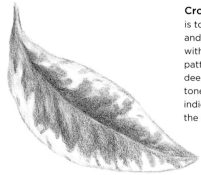

Croton Leaf The challenge here is to capture the hard surface and lovely variations in color with graphite. Outline the major patterns, and then draw in the deepest values with a 2B. Blend the tone, maintaining the values that indicate the color changes. Lift out the details along the edge.

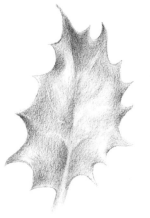

Holly Leaf With the side of a 2B, lay in some tone. Smudge the tone and lift out any areas that should remain white. The highlights will be important for creating the appearance of this leaf's glossy shine. Add deeper tones with a 4B (accenting the sharp points of the leaves and the raised veins), and then blend. Lift out the lighter veins.

PETALS

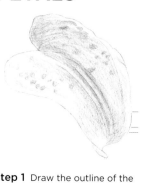

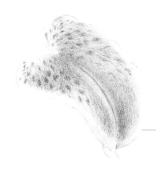

Step 1 Draw the outline of the petal. Then add the general shape of the coloration, some of the darker spots, and the raised center area. The strokes emphasize the petal's softness. Next darken the irregular spots and deepen the area along the center of the petal to bring out the raised parts.

Step 2 Deepen the shading of the colored areas, using long strokes that follow the direction of the petal and bring out its smoothness. Darken the markings and the center line, and then lightly shade the area where the petal folds back on itself.

Cactus Paddle The dark shading along the edge of this leaf defines its thickness. Add the shadows cast by the cactus fruit. Shade the diamond-shaped depressions on the leaf with a 2B, and lift out the raised areas. Place dots to emphasize the points where the sharp spines connect to the cactus.

BELLFLOWER

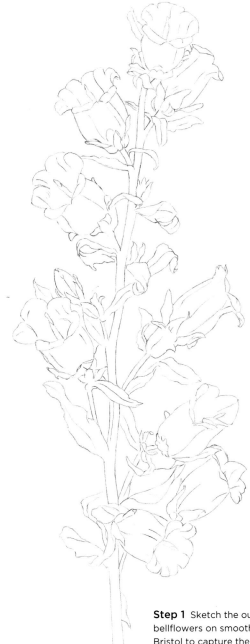

Step 1 Sketch the outline of the bellflowers on smooth, plate-finish Bristol to capture the shapes of the individual flowers and leaves.

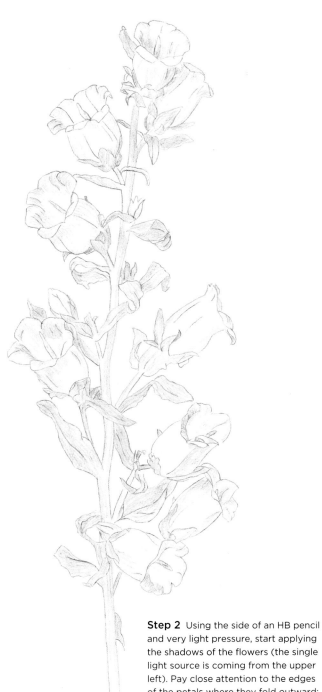

Step 2 Using the side of an HB pencil and very light pressure, start applying the shadows of the flowers (the single light source is coming from the upper left). Pay close attention to the edges of the petals where they fold outward; these curled petals are more delicate. Apply slightly heavier pressure for the leaves to create the hard edges, abrupt curls, and sharp twists. For the stigma, use small, circular strokes to gain the pollen-covered texture.

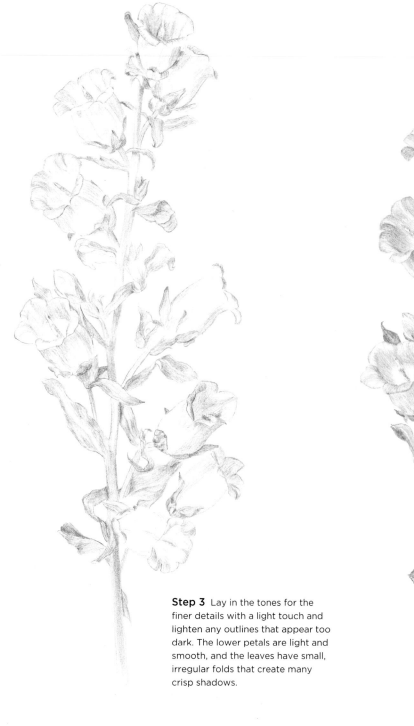

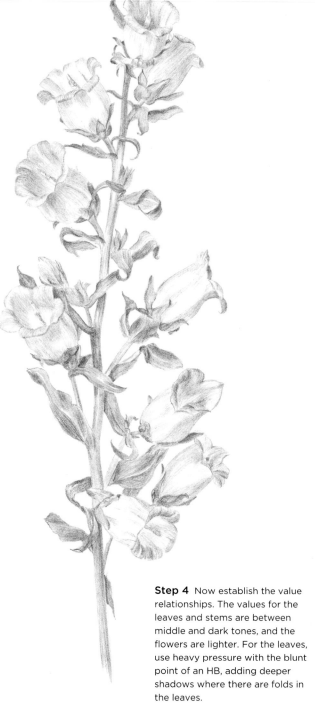

Step 3 Lay in the tones for the finer details with a light touch and lighten any outlines that appear too dark. The lower petals are light and smooth, and the leaves have small, irregular folds that create many crisp shadows.

Step 4 Now establish the value relationships. The values for the leaves and stems are between middle and dark tones, and the flowers are lighter. For the leaves, use heavy pressure with the blunt point of an HB, adding deeper shadows where there are folds in the leaves.

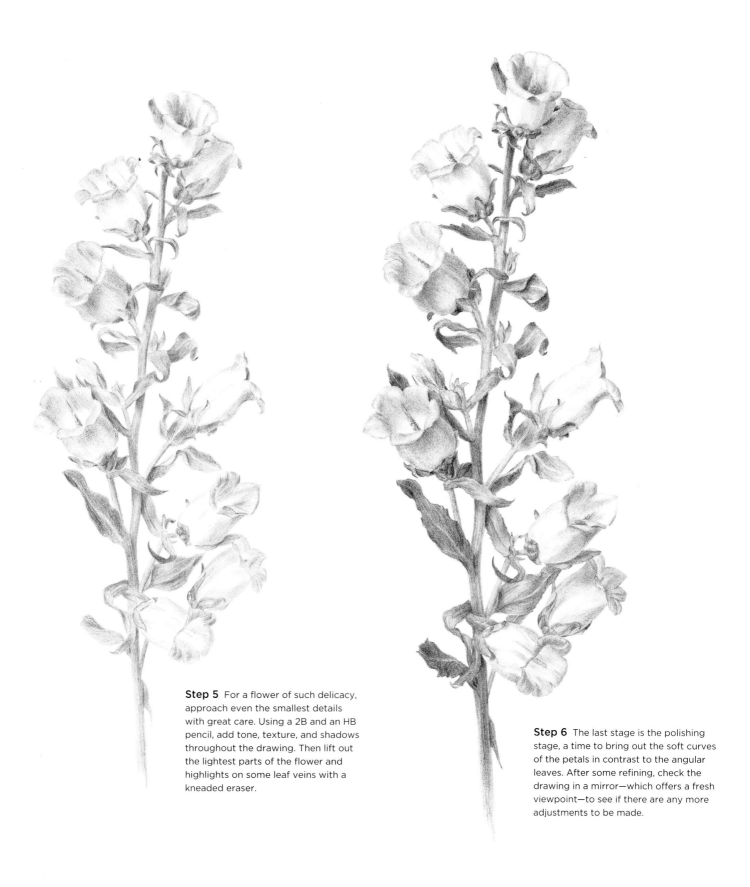

Step 5 For a flower of such delicacy, approach even the smallest details with great care. Using a 2B and an HB pencil, add tone, texture, and shadows throughout the drawing. Then lift out the lightest parts of the flower and highlights on some leaf veins with a kneaded eraser.

Step 6 The last stage is the polishing stage, a time to bring out the soft curves of the petals in contrast to the angular leaves. After some refining, check the drawing in a mirror—which offers a fresh viewpoint—to see if there are any more adjustments to be made.

TRADITIONAL STILL LIFE TEXTURES

Still life compositions allow you to have complete control: You design the composition; choose the range of textures, values, and colors; and create the ideal lighting situation. The best compositions have many contrasting textures, such as a smooth piece of fruit in a coarsely woven basket. Play around with different types of fruits and cheeses to see how the light catches their textures. It's always an added bonus to be able to share your food subject after your drawing is done!

FRUIT

Apple A polished red apple reflects a strong highlight, which contrasts with the skin's dark tone. Apply carbon dust (shavings collected from pencil sharpening) with circular, irregular strokes (top). Then lift out the highlight with an eraser (bottom).

Orange Apply carbon dust, using strokes that follow the fruit's form (top). Lift out the main highlight and use an eraser to create curved strokes around the highlight, showing the bumpy texture of the orange's skin (bottom).

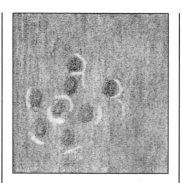

Strawberry Lay in dark tone with carbon dust and use a 4B to start establishing a dotted pattern for the strawberry (top). Continue to enhance the dimpled, seeded texture by adding thin, curved highlight lines around the darker dots (bottom).

Cantaloupe With the side of a 4B, lay down some tone and then randomly blend the graphite. Lift out a few lines to see how the lights contrast with the dark tone (top). Because the skin is very rough, there are no highlights—just the upper veining.

BASKETS WOOD

Weaves The texture of the basket's weave creates a three-dimensional pattern with many layers. Render a basket to learn about the interplay of light and shadow and how it can show the heavy texture of the basket.

Knotty Pine Zigzagged lines create the rough pattern of the grain. Use concentric ovals to draw the knots. Then use an HB to add light, straight vertical strokes and individual shorter strokes to show the raised grain.

Ash For this fine-grained wood, make long, inverted U shapes with a slightly uneven motion. Then draw very long grain lines, varying their density and allowing the lines to curve naturally. Go over these lines with light, vertical lines.

Zebrawood With a 4B, create the dark lines of this straight-grained hardwood. Group some closer together to indicate the color variation. Use a 2H to add very light tone with long, vertical strokes, adding a smooth quality.

WINE & CHEESE

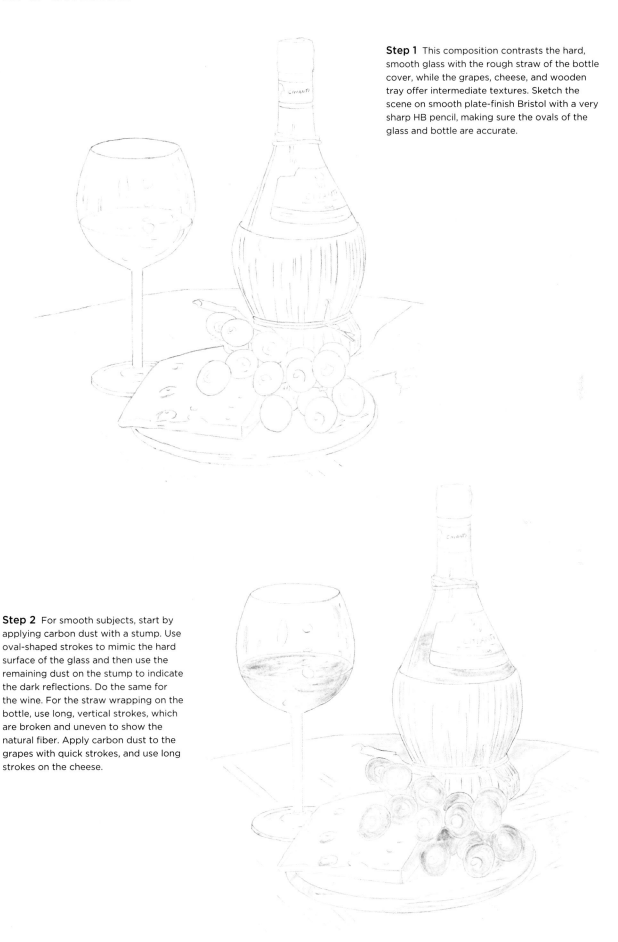

Step 1 This composition contrasts the hard, smooth glass with the rough straw of the bottle cover, while the grapes, cheese, and wooden tray offer intermediate textures. Sketch the scene on smooth plate-finish Bristol with a very sharp HB pencil, making sure the ovals of the glass and bottle are accurate.

Step 2 For smooth subjects, start by applying carbon dust with a stump. Use oval-shaped strokes to mimic the hard surface of the glass and then use the remaining dust on the stump to indicate the dark reflections. Do the same for the wine. For the straw wrapping on the bottle, use long, vertical strokes, which are broken and uneven to show the natural fiber. Apply carbon dust to the grapes with quick strokes, and use long strokes on the cheese.

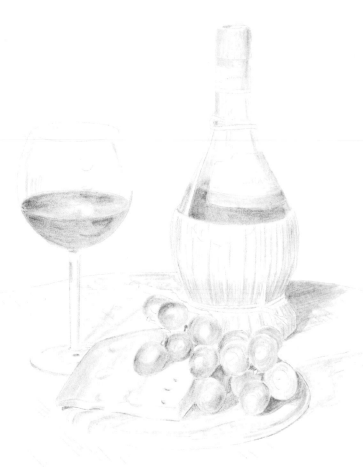

Step 3 Build up the glassy surfaces with a 2B pencil and a blending stump. Lightly shade the labels of the bottle. Blend the graphite on the straw and then establish soft shadows. Add shadows to the grapes and blend to create the slick skin. Apply more tone to the cheese with the stump and darken depressions in the cheese with the pencil. Add tone to the cast shadows on the table and then blend the strokes.

Step 4 Use a 2H pencil to give the glass sharp, crisp edges. Darken the wine in the bottle with the 2B. Then blend reflections in the glass and on the bottle with the stump. Deepen the grapes; redefine their distinct edges with a sharp HB and use the side of the pencil to add the thin stems. Shade the cheese with the HB and darken the wax rind with a 4B. Refine the delicate wood grain with an HB and draw in some details on the bottle labels.

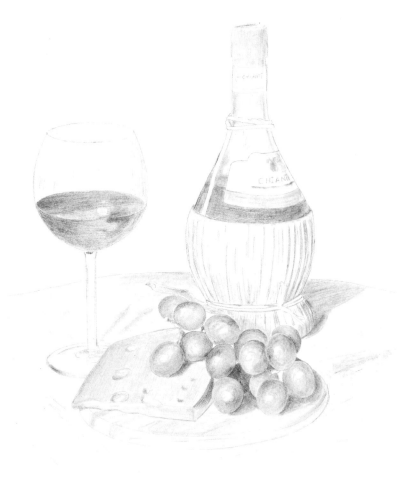

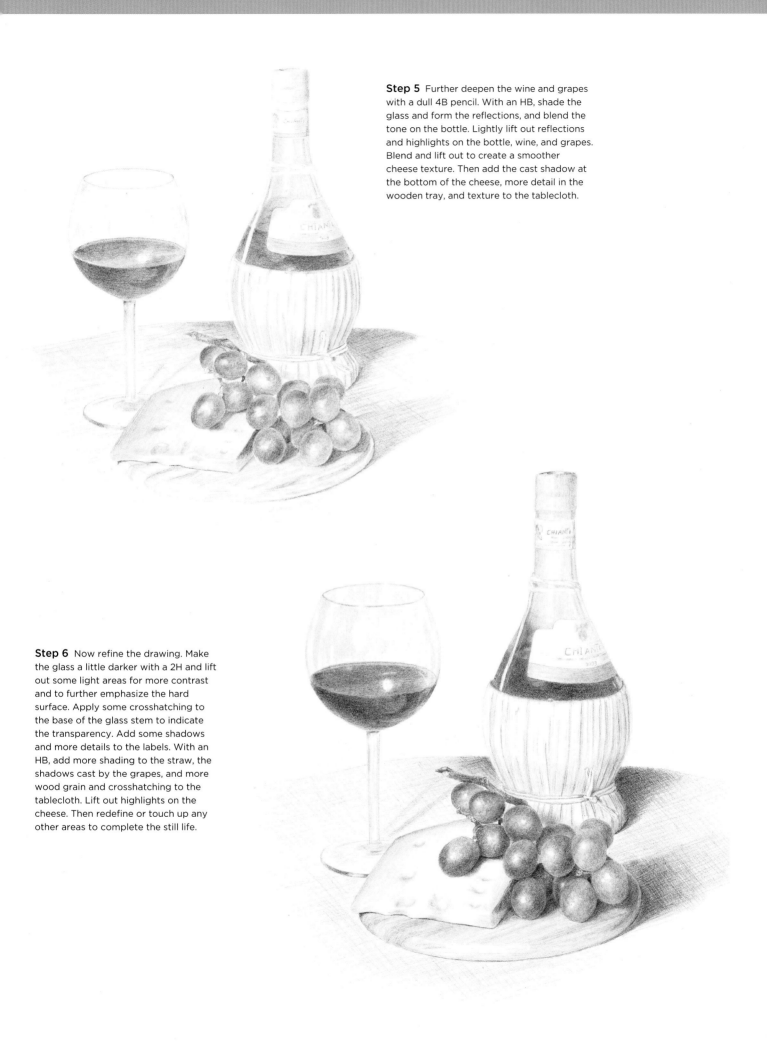

Step 5 Further deepen the wine and grapes with a dull 4B pencil. With an HB, shade the glass and form the reflections, and blend the tone on the bottle. Lightly lift out reflections and highlights on the bottle, wine, and grapes. Blend and lift out to create a smoother cheese texture. Then add the cast shadow at the bottom of the cheese, more detail in the wooden tray, and texture to the tablecloth.

Step 6 Now refine the drawing. Make the glass a little darker with a 2H and lift out some light areas for more contrast and to further emphasize the hard surface. Apply some crosshatching to the base of the glass stem to indicate the transparency. Add some shadows and more details to the labels. With an HB, add more shading to the straw, the shadows cast by the grapes, and more wood grain and crosshatching to the tablecloth. Lift out highlights on the cheese. Then redefine or touch up any other areas to complete the still life.

FLORAL STILL LIFE TEXTURES

Flowers come in so many interesting forms, colors, and textures; it's no wonder they are an endless inspiration for artists! When setting up a floral still life, keep your containers and arrangements simple, with a textural quality that won't overwhelm the flowers.

GLASS

Opaque Gloss Vase Apply carbon dust, and then lift out the bright highlights. For the subtle highlights, drag an eraser lightly across the tone of the vase.

Opaque Matte Vase This vase hardly has any highlights. Use an HB and make crisp edges to show the hard, smooth surface.

Clear Vase This vase is transparent, so the back of the vase can be seen from the front. There also are sharp highlights and reflections. Use a 2H for shading.

CERAMIC

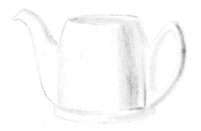

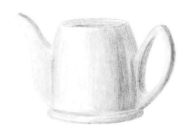

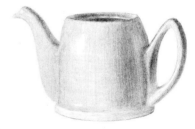

Step 1 Glazed ceramic clay is hard and reflective. Create a "wash" with carbon dust and a stump; then establish the shadow patterns. Follow the form of the teapot with vertical strokes.

Step 2 With a sharp HB, draw light, vertical strokes that follow the contour of the teapot. Then use strokes that reach across the teapot horizontally, particularly around the base.

Step 3 Build up the values of the teapot with vertical and horizontal strokes, and then use the stump to blend. For crisp contrasts, use an eraser to lift out highlights and spots of reflected light.

FABRICS

Fringe Use a sharp HB to draw a detailed outline of the fringe and knots. The strands should be slightly frayed, reflecting the softness of the thread.

Crochet Lace and crocheted fabrics have holes that add a lovely textural element. The holes create heavy shadow, but the fabric is still light and delicate.

PITCHER OF LILIES

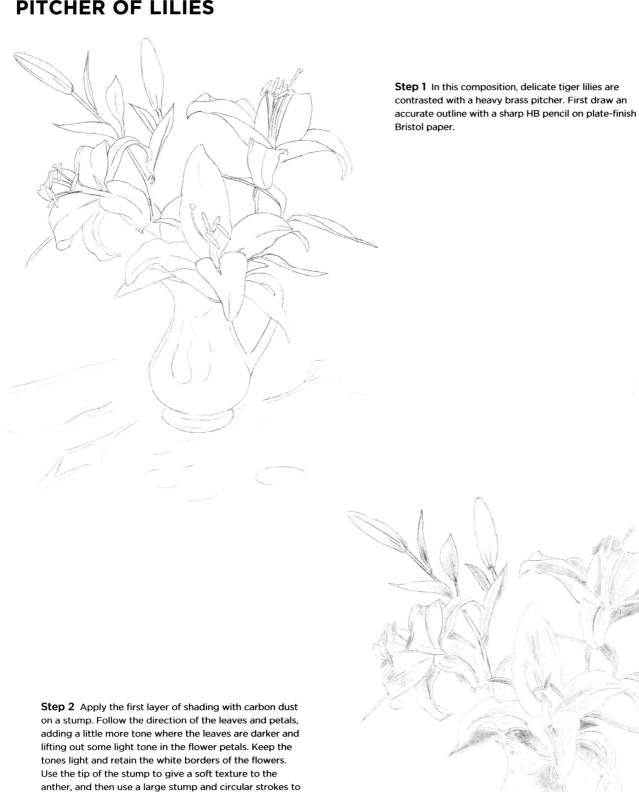

Step 1 In this composition, delicate tiger lilies are contrasted with a heavy brass pitcher. First draw an accurate outline with a sharp HB pencil on plate-finish Bristol paper.

Step 2 Apply the first layer of shading with carbon dust on a stump. Follow the direction of the leaves and petals, adding a little more tone where the leaves are darker and lifting out some light tone in the flower petals. Keep the tones light and retain the white borders of the flowers. Use the tip of the stump to give a soft texture to the anther, and then use a large stump and circular strokes to shade the brass pitcher.

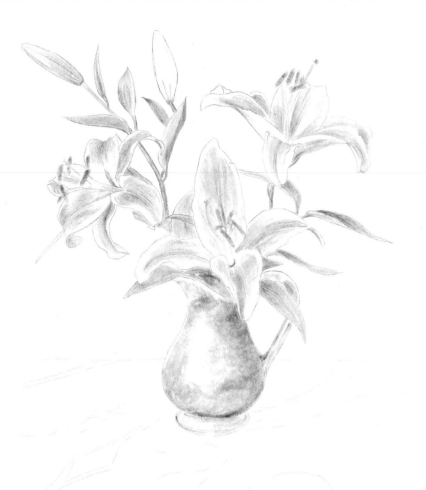

Step 3 Use a 2B pencil and long strokes to add more tone to the stems and the leaves. Start adding tone to the petals, using a little more pressure in the centers and at the base of the petals. Use a 6B on the anthers and the stigma, and a 2B on the style and at the base of the flower where the pistil and stamen emerge. For the two flower buds, add just a little shading where the soft petals join the stem. Deepen the pitcher with circular strokes, placing darker tone at the base and along the handle. Then blend the strokes.

Step 4 Use a 2B and long strokes to deepen the shadowed sides of the stem. Shade the leaves, using a 4B in the darkest areas. While working on the leaves, alternate between a pencil and a blending stump. Allow some strokes to be more obvious to capture the appearance of the veining in the leaves. Darken the undersides of some of the petals, keeping the strokes soft looking. Use the side of a 6B pencil to shade the pitcher irregularly. Then lift out to maintain the highlight. Add some tone to the table where the cast shadow falls and then wipe it with a chamois cloth to smooth it.

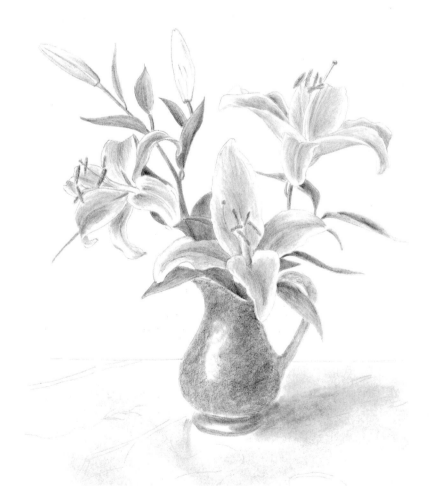

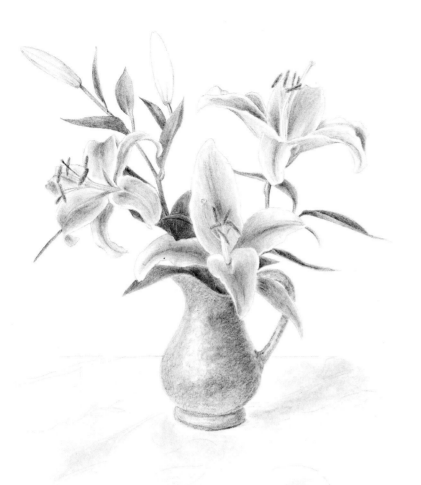

Step 5 Now refine the shading to show more texture. Use a pencil, a stump, and an eraser to create even tones and delicate transitions between strokes. With the pencil point, add small cast and form shadows, such as where the buds and the leaves attach to the stem. Delicately shade the buds using an HB and long, light strokes. Smooth the tone on the velvety, soft petals and then touch up the edges. Use a 4B with tiny, circular strokes to shade the anthers. Then add more tone to the pitcher with a 6B, leaving the strokes rough for the metallic texture. Lightly lift some tone from the edge of the right side.

Step 6 Again darken the leaves with smooth, steady strokes, and lift out some thin venation lines. For the petals, further refine the tonal shading, lift out the white borders, and add the flat spots that are so characteristic of lilies. Smooth out the pitcher using a 4B with small, circular strokes, and then use the point of the pencil to better define the edges at the base. Stipple in some dots with a 6B and randomly dab with the tip of the eraser to create the feel of the pitting. Add light tone on the table using horizontal strokes with the side of the pencil. Use just a little pressure to deepen the embroidery pattern of the tablecloth. Finally, darken the shadow cast by the arrangement.

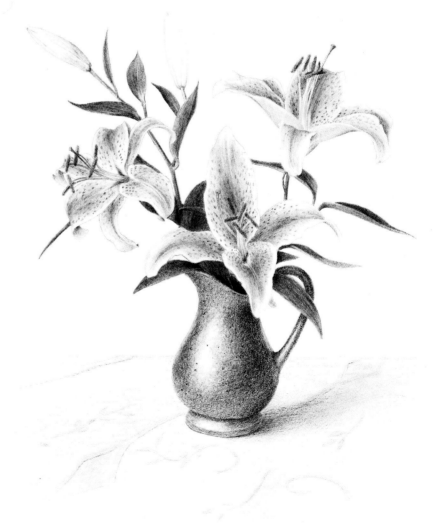

WILDLIFE TEXTURES

Nature provides some of the most exquisite and interesting textures. Drawing wildlife is especially helpful because each animal comprises a number of different textural elements. Think about a bird with its sleek feathers, scaly feet, smooth beak, and glistening eyes. What more could an artist ask for?

FEATHERS

 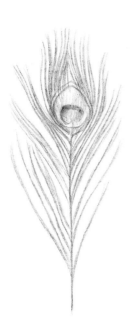 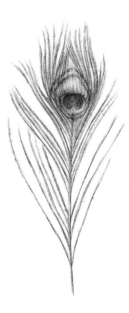

Step 1 Start drawing the peacock feather with thin lines that stem from a vertical centerline. Then draw a circle within an oval for the "eye"—curve the lines that surround the "eye" so that they follow the ovular form.

Step 2 Darken the center of the "eye" to emphasize the distinctive pattern. Keep the area around the center light to indicate the change in color and the delicate feather texture.

Step 3 After darkening all of the lines, use a kneaded eraser to lift out a small curve along the edge of the dark center.

LIFTING OUT FOR FEATHERS

After using an eraser to lift out the white edges of the feathers, reinforce the defined edges with pencil. Use short lines that follow the direction of the feathers to create additional texture. Then blend the background with an eraser to make the feathers stand out.

SCALES AND SKIN

 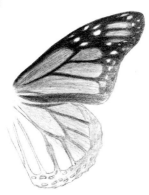

Alligator Use a soft, broad pencil with plate-finish paper, as rough paper will interfere with the leathery, bumpy texture of the alligator's skin. Pay attention to the light source; alligator skin is made up of many small ridges, and each ridge must be lit properly for it to appear realistic.

Butterfly Outline the wing with a sharp HB pencil, and lightly draw the thin veins. Then put down a layer of tone all over. Deepen the veins with a 2B, gradually increasing the pressure on the pencil. With the HB and long strokes, deepen the light tones, allowing some strokes to be darker for slight variation.

Frog Frog skin is usually moist, so the smudging technique (see page 85) is appropriate. Use darker tones to create the raised bumps and lift out some graphite to add highlights to the slimy surface to give a wet look to the entire skin.

Fish First outline the scales, paying careful attention to the details. Then add shading at the base of the scales where they overlap to show the distinctive flaky texture. Note that every scale has a highlight— this helps capture the fish's shimmery nature.

BLUE JAY

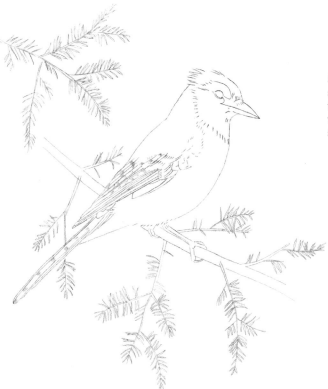

Step 1 Begin by drawing a detailed outline with a sharp HB mechanical pencil. Use short strokes on the head to create the softer edges of the feathers there. Indicate the blue jay's black markings with some quick shading.

Step 2 With a sharp 2H pencil, darken the lines around the feathers to define them, and add some dark markings using short strokes. Make sure your strokes follow the direction of the feathers. Shade under the wings, but don't make the shadows too dark at this point. Darken the eye, leaving the highlight white and using tiny strokes that follow the form of the sphere. Switch to an HB to outline the rigid beak. Put some tone in the beak but leave it lighter on the upper part.

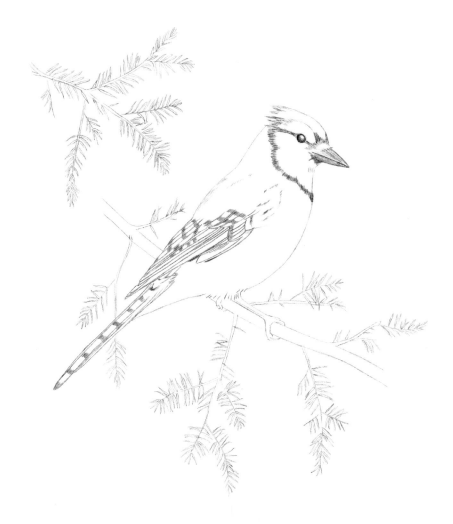

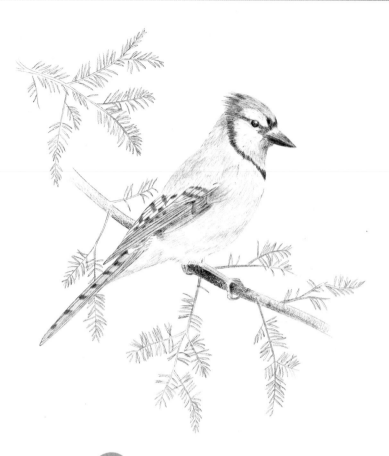

Step 3 Begin the shading that will contribute to the sense of the bird's form but remember to maintain the softness of the feathered body. Work back and forth between an HB and a 2B pencil and begin developing values throughout the bird using different strokes. Then use a broad-point 6B pencil to shade the branch with circular strokes, lightening the shading as it recedes into space.

TIP

Balance the values of the form with the values of the color while keeping the textural elements intact. The form values are the values created by the light hitting the blue jay, whereas the color values are the ones representing the different colors of the actual bird. The texture emerges from the way these values are applied. In pencil, white is expressed as light shading, blue is the midtone, and black is the darkest shading. If you run into a conflict between the form and color values, give priority to the form values.

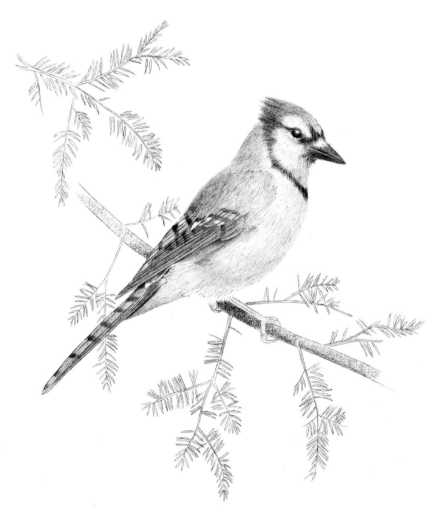

Step 4 With a sharp HB pencil and short strokes, deepen the black markings, leaving the white markings free of any tone. Indicate shadows using the side of a 2B pencil. Then deepen the tone on the back and the belly. Leave a few little lines that extend beyond the edge of the bird, producing the feathered texture.

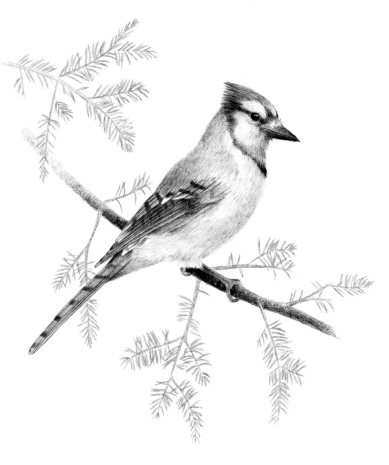

Step 5 Now focus on creating smoother and more natural tonal transitions. Further develop the eye, darken the beak, add some longer, deeper lines to the back of the crown, and add a few short, light strokes in the white area of the head. Keep those lines light, so as to not lose the value of the white. Switch to a dull 4B to darken the feet with circular strokes and add a small shadow under them. Deepen the tone of the branch with heavier, irregular, circular strokes, using a broad 6B. Then add some light shading in the pine needles using a few long strokes and an HB.

Step 6 With a 2B pencil, further deepen the wings and darken the shadowed belly tones. Add a few long, sharp lines to indicate the smooth edges where the feathers overlap, and add some short, sharp lines for the small feathers at the upper base of the beak. Use a 4B to give form to the small branches and a blunt 4B to add tone to some of the needles. Lift out just a touch of graphite for the reflected light at the bottom of the main branch. Clean up the drawing with a kneaded eraser and lift out any white markings you need to add to the feathers. Look the art in a mirror to see if there are any areas that you are not satisfied with, and adjust the drawing accordingly.

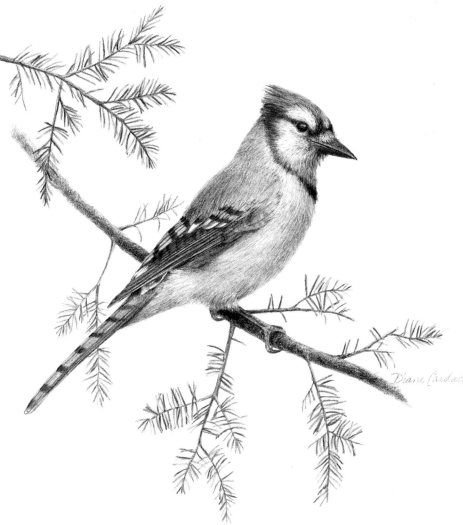

LANDSCAPE TEXTURES

When there are a lot of trees, rocks, and other natural elements in a landscape, it can seem overwhelming to try to capture all of the textures. To simplify the process, start by mapping out the major masses of the landscape elements, breaking them down into more manageable shapes. Then add other textural aspects, such as clouds and water, which bring the scene to life.

LAND

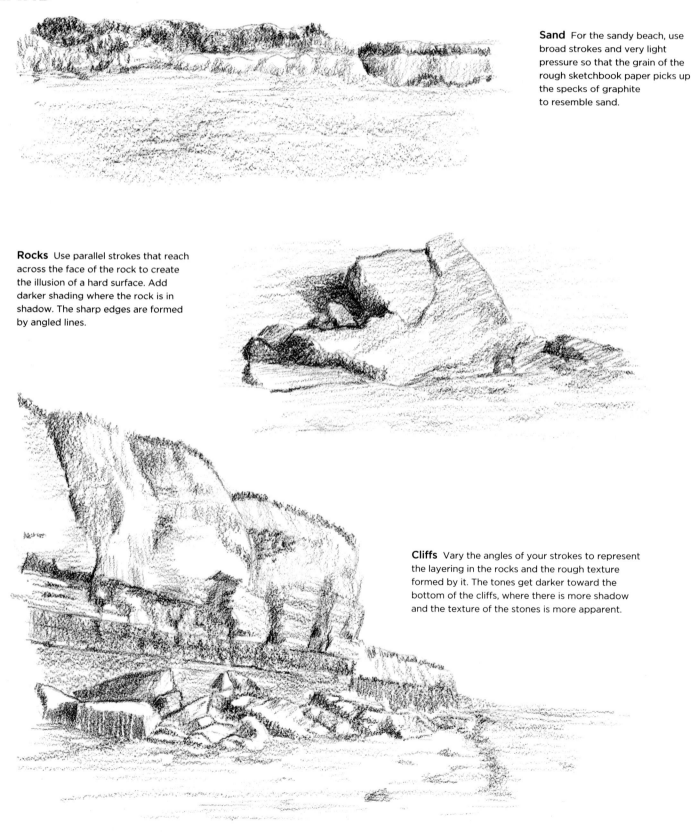

Sand For the sandy beach, use broad strokes and very light pressure so that the grain of the rough sketchbook paper picks up the specks of graphite to resemble sand.

Rocks Use parallel strokes that reach across the face of the rock to create the illusion of a hard surface. Add darker shading where the rock is in shadow. The sharp edges are formed by angled lines.

Cliffs Vary the angles of your strokes to represent the layering in the rocks and the rough texture formed by it. The tones get darker toward the bottom of the cliffs, where there is more shadow and the texture of the stones is more apparent.

CLOUDS

 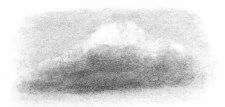

Cumulus For fluffy clouds, dab an eraser gently for light gray areas and use more pressure to lift out the whites.

Cirrus To draw these wispy clouds, lift out using a curving motion and then extend that motion horizontally.

Cumulonimbus To capture these dark storm clouds, dab the graphite with an eraser; then add dark tone and blend.

WATER

Still Water When the air is perfectly still, water can appear almost like a mirror, reflecting objects clearly. To make the reflections evident, use dense, dark strokes.

Rougher Water Allow the lines to be wavier than in the previous example. Lift out with long, horizontal strokes. No reflections can be seen.

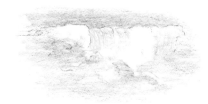 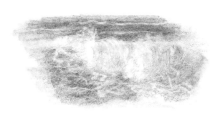

Waves Waves produce a sense of movement through frothy white caps. Start with the shape of the wave, create the darker parts of the water with a 4B, and blend.

To finish the wave, create a few white lines in the dark tone with an eraser, showing the building white caps. Dab the eraser to create the spray and lift out wavy shapes to make the foam.

TREES

Painterly Strokes Use a wide, soft lead to lay down large, dense areas of tone. Finish with some shorter strokes, stippling to create detail and add texture. This gives a tree an open, leafy pattern.

Linear Strokes Use a sharper pencil and small, thin strokes. Vary the direction and density of your lines to develop the dark and light values that establish the form of the tree. This technique is ideal for prickly pine trees.

Combining Techniques Put down some tone and then smear it with a blending stump. Then use short, linear strokes with a sharp pencil to create the texture. This creates a tree with a softer-looking texture.

LAKE SCENE

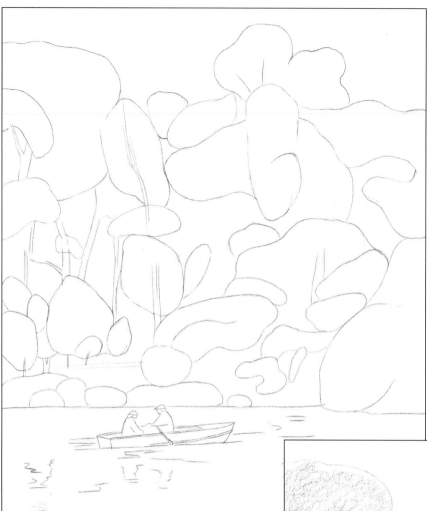

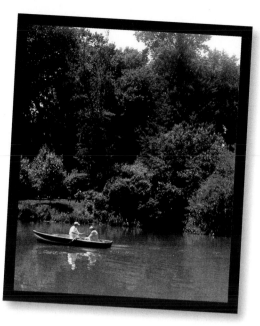

Taking Artistic License You have the freedom to change elements of your photo references. To improve the composition of this drawing, the direction of the boat is changed.

Step 1 Think of a scene as a sort of jigsaw puzzle of light and dark shapes. Look for the major organic shapes and leave the smaller ones for a later stage. Draw in just a few major shapes, such as the trunks and branches of trees, and don't include any details or worry about textures yet. Indicate just a few lines for the water so you know where the darkest areas are.

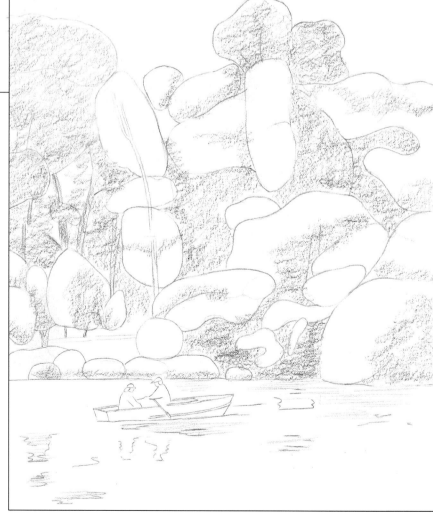

Step 2 Using the side of a 6B pencil, lay in tone for the large masses of foliage. Use long strokes for the trunks. With the side of an HB pencil, lightly put down some preliminary tone in horizontal strokes to show the calm water.

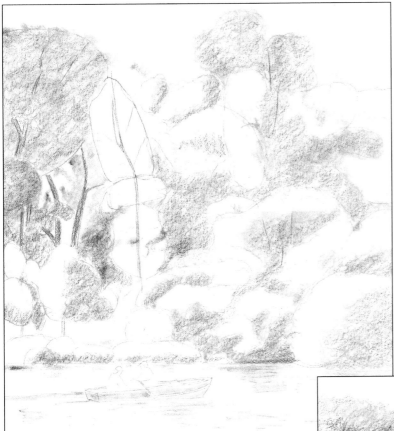

Step 3 Continue developing the masses with a thick blending stump. You are painting more than drawing, creating a wash effect by loosely smearing the tones you have already put down. Then use a sharp HB to create the hard edges of the tree trunks and branches. Dip your stump into some carbon dust and apply it to the darker areas of the water. With a thin stump, apply a "wash" to the boat.

Creating Bark Use the side of a 2B to shade the bark of the trees, varying your lines so the patterns aren't rigid. Once the tone is built up, go back and accentuate the grooves with the point of your pencil. Then lift out with an eraser. The more range you create between the lightest and darkest tones, the rougher the bark will appear.

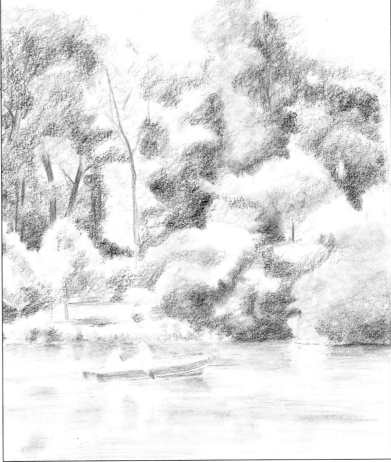

Step 4 Now start defining the shapes and textures of the foliage masses. Using a 6B, go back in with loose strokes and put more tone in the darker, smaller masses. Break down the light and dark areas and refine their shapes. For the water, use the side of an HB, allowing your hand to create slight waves in the lines. Add another layer of carbon dust with the stump where the tonal variations occur in the water.

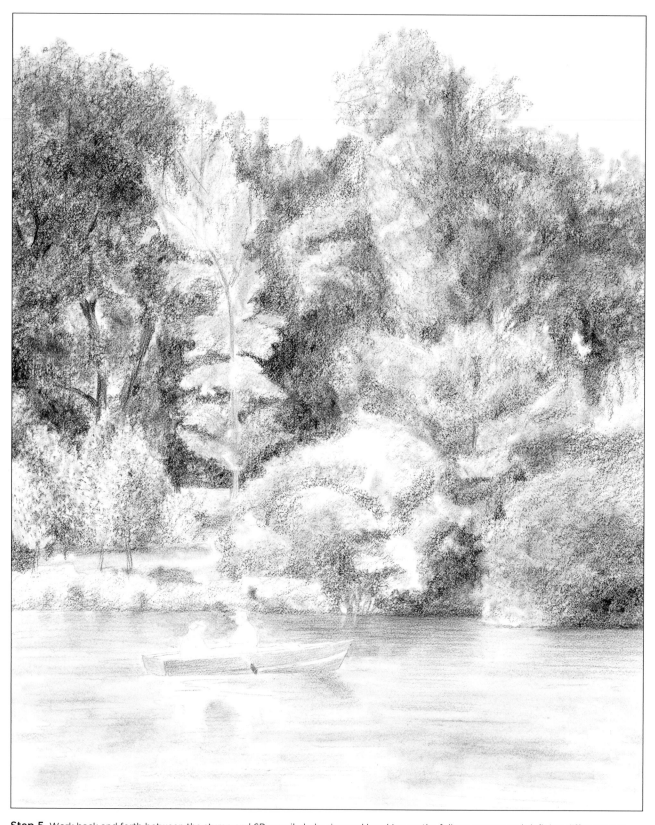

Step 5 Work back and forth between the stump and 6B pencil, darkening and breaking up the foliage masses and defining differences in the textures they create. Work freely, allowing accidental effects to create more atmosphere. Use a sharp 2B for some branches. For the small trees near the water, use a 6B to stipple, creating more stippling where the form turns away from the light. Repeat the same process used earlier for the water and darken the shadowy areas. Use the deepest tone along the bank, leaving some areas lighter based on the shape and textural quality of the reflections.

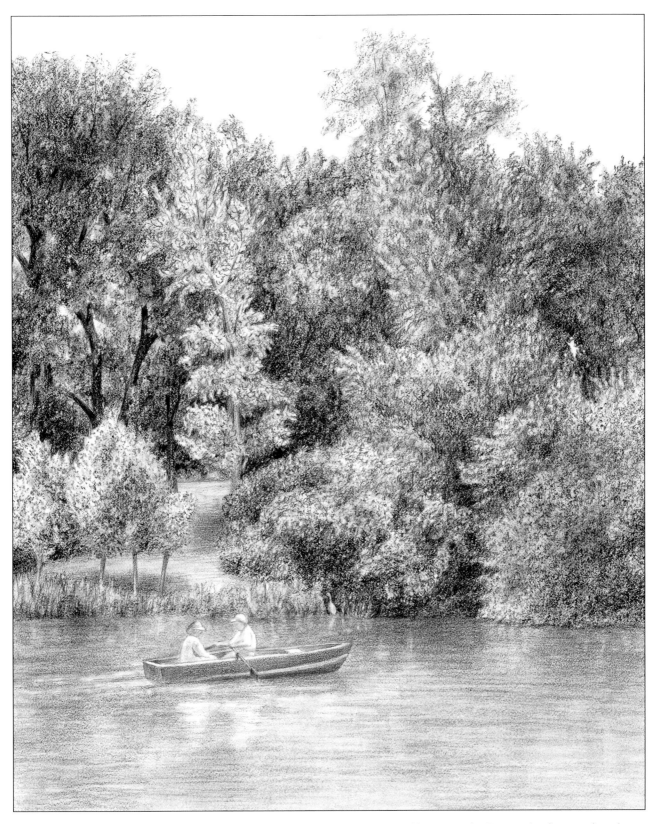

Step 6 Lightly stipple along the branches that extend into the sky to create an illusion of leaves; use the 2B to put in a few more branches; and draw some small, curved strokes with a 4B, adding individual texture to the trees. Use the stump and add a few pencil strokes for the grassy area. With the kneaded eraser, pick out additional lights in the foliage, boat, and water. Carefully define the shape of the bird by the shore and the trunks of the small trees with the sharp point of an HB. Finally, add just a little shading to the people.

ANIMAL TEXTURES

Once you've mastered the subtleties of rendering fur and hair textures, you'll be able to draw a whole zoo full of animals! Animals are more than their coats. For example, a dog has a wide array of textures to experiment with, from the shining eyes to the wet nose.

FUR AND HAIR

Curly Create a base tone using carbon dust and a stump. Then lift out long, curly, white lines to achieve the kinky texture of the hair. Add curly lines on top of the white areas with a very sharp HB pencil.

Silky Outline the prominent hair patterns with an HB and then put in some tone with strokes that follow the gentle waves of the hair. Then use an eraser to pick out shiny highlights.

Short and Wiry Put down some carbon dust and blend with a stump, using short strokes when blending. Draw short lines to develop the hair growth patterns and make slight changes to the direction of individual hairs to produce the wiry texture.

Short and Smooth Lay in tone using carbon dust. Then make several very short strokes with the side of a 2B pencil to achieve the smooth-textured appearance.

Long and Fluffy Put down a base tone; then add some long, slightly curved, light strokes with the side of a 2B. On top of that, put in thin lines with the point of the pencil and add some heavier lines where the hair is darker.

Long and Smooth Draw long, wavy lines, and then add tone with carbon dust. Alternate shading with the side of the pencil, drawing fine lines with the point of an HB, and lifting out white areas with an eraser to get the soft look.

YORKSHIRE TERRIER

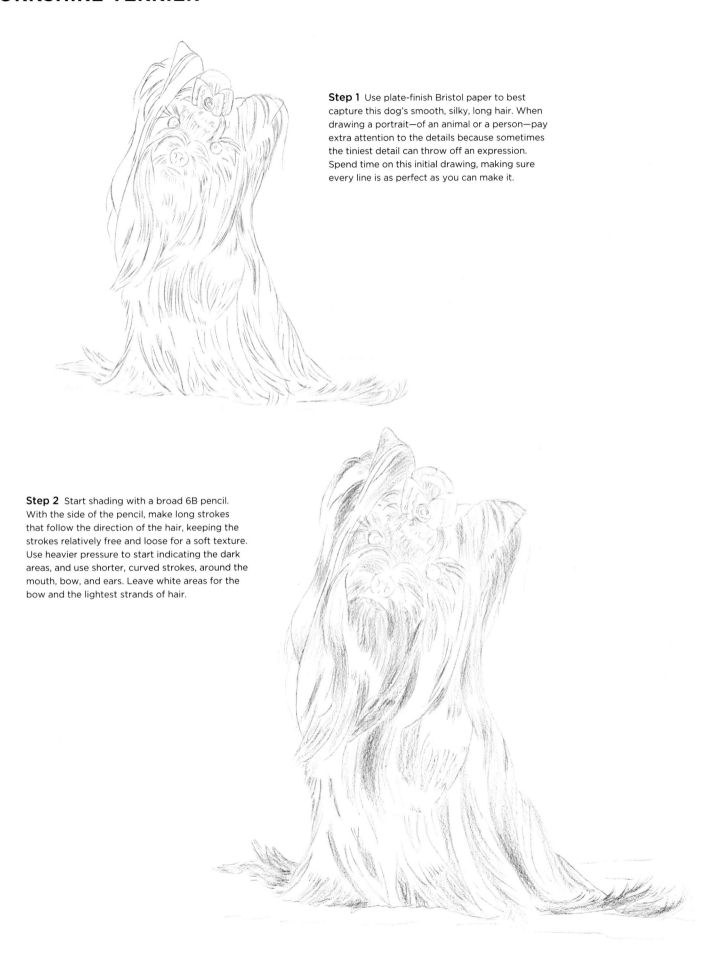

Step 1 Use plate-finish Bristol paper to best capture this dog's smooth, silky, long hair. When drawing a portrait—of an animal or a person—pay extra attention to the details because sometimes the tiniest detail can throw off an expression. Spend time on this initial drawing, making sure every line is as perfect as you can make it.

Step 2 Start shading with a broad 6B pencil. With the side of the pencil, make long strokes that follow the direction of the hair, keeping the strokes relatively free and loose for a soft texture. Use heavier pressure to start indicating the dark areas, and use shorter, curved strokes, around the mouth, bow, and ears. Leave white areas for the bow and the lightest strands of hair.

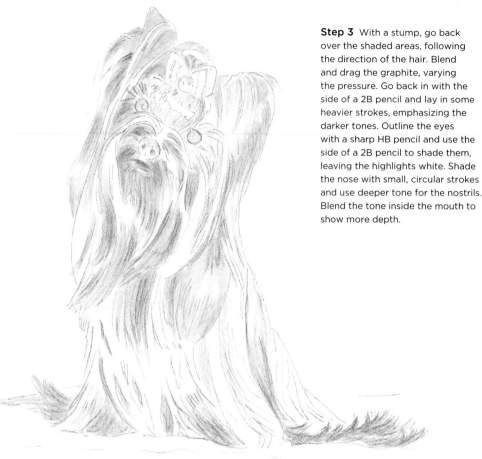

Step 3 With a stump, go back over the shaded areas, following the direction of the hair. Blend and drag the graphite, varying the pressure. Go back in with the side of a 2B pencil and lay in some heavier strokes, emphasizing the darker tones. Outline the eyes with a sharp HB pencil and use the side of a 2B pencil to shade them, leaving the highlights white. Shade the nose with small, circular strokes and use deeper tone for the nostrils. Blend the tone inside the mouth to show more depth.

CANINE EYES

Eyes are the windows to the soul. It's important to draw them with plenty of expression. A dog's eye is different than a human's, so pay close attention to the tones you use.

Step 1 Outline the eye; then use circular strokes to create a base tone. Put darker shading in the center of the iris for the pupil, as well as around the outer edge. Leave the square-shaped highlight white.

Step 2 Next deepen the tone in the pupil, around the outside of the iris, and along the eyelids. The contrast of the dark pupil against the white highlight makes the highlight appear even brighter.

Step 3 Maintain a sharp edge for the highlight, which gives the eye a wet, glossy look. Shade around the eyes using short strokes with the side of the pencil; then draw a few hairs around the eye with a sharp point.

Step 4 Now define the texture of the silky hair patterns. With a sharp 2B, draw long strokes, curving them where the hair is wavy. Use short, curved strokes where the hair gathers at the bow and the shorter hairs around the face. With the side of an HB, add deep shading around the edge of the eyes. Also continue to deepen the value on the nose while maintaining the distinct texture. Then use an eraser to lift out some highlights in the hair.

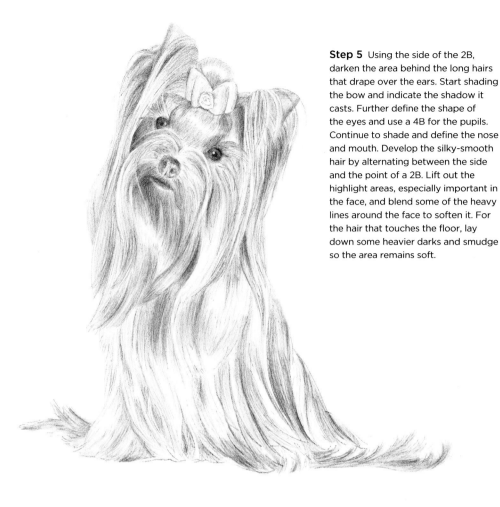

Step 5 Using the side of the 2B, darken the area behind the long hairs that drape over the ears. Start shading the bow and indicate the shadow it casts. Further define the shape of the eyes and use a 4B for the pupils. Continue to shade and define the nose and mouth. Develop the silky-smooth hair by alternating between the side and the point of a 2B. Lift out the highlight areas, especially important in the face, and blend some of the heavy lines around the face to soften it. For the hair that touches the floor, lay down some heavier darks and smudge so the area remains soft.

CANINE NOSES

A dog's nose is wet and leathery; it's an interesting combination of rough and shiny textures.

Step 1 Draw an outline of the nose with the highlights clearly delineated. Use circular strokes with a 4B to create the base tone. Then put darker tone in the nostrils.

Step 2 Add another layer of tone, still using circular strokes to build the leathery texture. Leave white spots for the highlights on the top of the nose and around the edges of the nostrils.

Step 3 Make the deep part of the nostrils as dark as possible. Break up the highlights with a few strokes, but make sure to keep them white and visible because the highlights create the illusion of wetness.

Step 6 Now bring everything into sharp focus. Darken some areas throughout. Create a crisp highlight in the eye with an HB pencil and be careful to leave the highlights on the nose. Then develop the strands of hair that stand out around the face. To do this, alternate between lifting out the light areas and softly shading the darker areas. Then add some sharp, fine lines around the face, including the shorter, dark hairs below the mouth. Work on the body hair, lifting out more highlights to add a silky shine. Finally, use circular strokes with a broad 6B to create a soft, carpetlike texture for the floor.

PORTRAIT TEXTURES

Capturing a likeness can be one of the greatest challenges for an artist, yet it also can be incredibly rewarding. Careful observation, coupled with a thorough understanding of the form of the head, is the foundation of a successful portrait. Consideration must be given to how the light flows over the head and facial features, as well as the very different textures of hair, teeth, skin, and eyes.

HAIR

Light and Wavy Carbon dust and a stump create a base of light, subtle tone. Add long, flowing lines, following the soft waves of the hair. The strands in the foreground stay very light to emphasize the color of the hair.

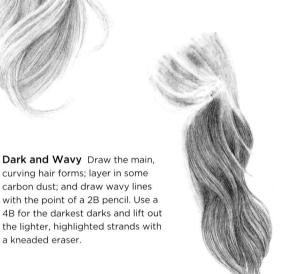

Dark and Wavy Draw the main, curving hair forms; layer in some carbon dust; and draw wavy lines with the point of a 2B pencil. Use a 4B for the darkest darks and lift out the lighter, highlighted strands with a kneaded eraser.

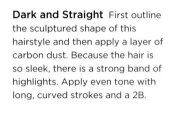

Dark and Straight First outline the sculptured shape of this hairstyle and then apply a layer of carbon dust. Because the hair is so sleek, there is a strong band of highlights. Apply even tone with long, curved strokes and a 2B.

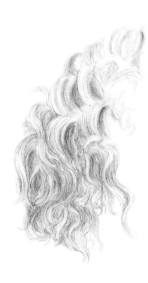

Light and Curly Outline the main masses of curls and some individual hairs. Then use a sharp HB to shade. Lay in some carbon dust for the hair that is in shadow. Then lift out some highlights with curved strokes.

FABRICS

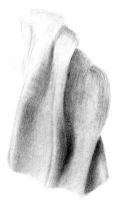

Flannel Apply carbon dust using circular strokes. Then layer in long strokes with a 2B and blend, keeping the highlights soft and subtle.

Woven These highlights aren't sharp, but the tone is lighter where the light hits. Use crosshatching to shade, achieving a heavily woven texture.

Satin Draw the main folds. Then apply a layer of carbon dust. Define the highlights with an eraser for shine, and lift out for the stitches.

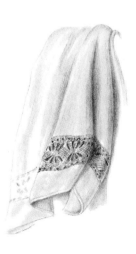

Lacework This fabric is matte, so the tonal transitions are very soft with no bright highlights. Make the dark holes with a sharp 2B.

YOUNG GIRL

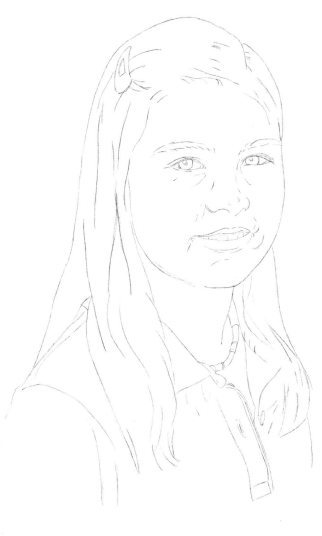

Step 1 Smooth Bristol paper is best for capturing the subtle details in portraits. Use a sharp HB pencil for the outline of the basic features of the head. Check and recheck the accuracy of your drawing because the slightest errors in observation will take away from the likeness of the subject.

Step 2 With the side of a 2B pencil, draw long, flowing strokes that follow the direction of her smooth, straight hair. Put light tone in the irises with small, circular strokes. Use long strokes with a slight curve for the side of the nose, but for the tip, think of a small sphere and use shorter, curved strokes. Add light strokes on the side of the face. Indicate the shadow directly under the eyebrow on the left and the lower lip. Then draw lines that indicate the shape of the neck and add some darker tone for the cast shadow under the collar.

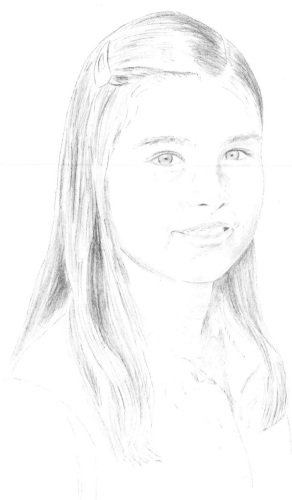

Step 3 Begin to blend the hair with a large stump. Then go back and lay in more tone with a 4B for definition around the area where the hair parts and around the side of the face. With the lightest touch, blend the pencil strokes around the side of the face, following the contour of the cheeks. With a smaller stump, lightly blend the areas around the facial features. Then use a 2B pencil to put some deeper tone throughout the face. Work in light layers to slowly develop the form, studying the subject as you draw.

Step 4 Using the point of the 2B pencil, build up the tone and flow of the hair. Alternate between a pencil and a stump, being careful to retain the highlights. Work on the face, using a delicate buildup of crosshatching. Draw very light, long strokes with an HB across the smooth skin of the forehead. Shade around the eye area, nose, lips, cheeks, and chin, and put very subtle shading on the teeth. Deepen the irises with a 2B and lift out for the highlights. Work on the neck and necklace. For the collar of the shirt, keep your strokes farther apart to develop a feel of the knit fabric.

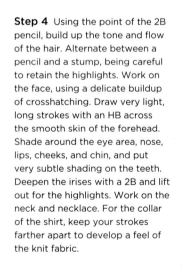

DRAWING EYES

Step 1 Start with an outline of the eye; then dip a stump into some carbon dust and apply a light layer of shading, following the contours of the eye and eyelid. Use radial strokes for the iris.

Step 2 Use the point of the stump to apply shading to the fold of the eyelid. Darken the iris but maintain the sharpness of the highlight, lifting out with a kneaded eraser wherever the area might have become shaded from the carbon dust.

Step 3 Switch to an HB for the eyelids and eyeball, using smooth, curved strokes on the lid. Deepen the iris with a 2B; then lift out a few specks to give the eye a more realistic look. Darken the pupil and add delicate eyelashes.

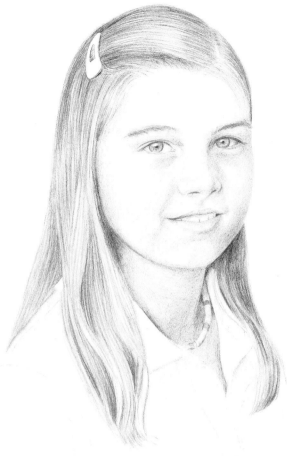

Step 5 Now begin refining the face. Continue building up the tone of the silky hair, using a 4B for the darks and a 2B for the lights. Deepen the shadow areas between the face and the hair to give depth to the face. Use a kneaded eraser to delicately lift out where tones are built up too much. Darken the eyebrows and irises. Use an HB in the detailed areas where you need a sharper point, like the folds of the eyelids or the edges of the lips. Continue to build up the neck and shade the necklace.

RENDERING LIPS

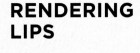

Step 1 Start with an outline of the mouth and apply light tone with carbon dust and a stump.

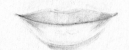

Step 2 Add another layer of tone with the carbon dust and darken underneath the bottom lip and in the corners of the mouth. Switch to an HB pencil and stroke outward with short, slightly curved lines, leaving white highlights.

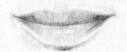

Step 3 With the side of the pencil, add more tone to the lips, lifting out the highlights. Use a 2B to draw the separation of the lips; then add more contour lines with an HB. Add a touch of carbon dust to the corners of the mouth.

Step 6 Continue to build up the tone of the hair and lightly shade the barrette, putting in small cast shadows with a sharp point. With the HB, continue to crosshatch the face to refine the transition between the tones, using a 2H in the lightest areas of the cheek. Deepen the eyelashes with short lines. Then refine the nose, mouth, gums, and teeth. For the fiber texture of the necklace, use a soft 6B to pick up a bit of the paper's grain. Then lift out the sharp highlights of the metal beads. Finally, work on the shirt with crosshatching. Then add a line for the buttonhole and the round button.

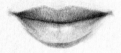

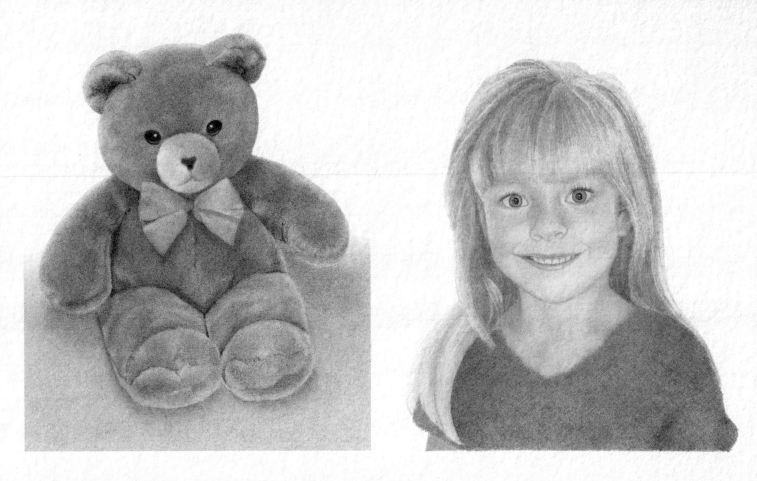
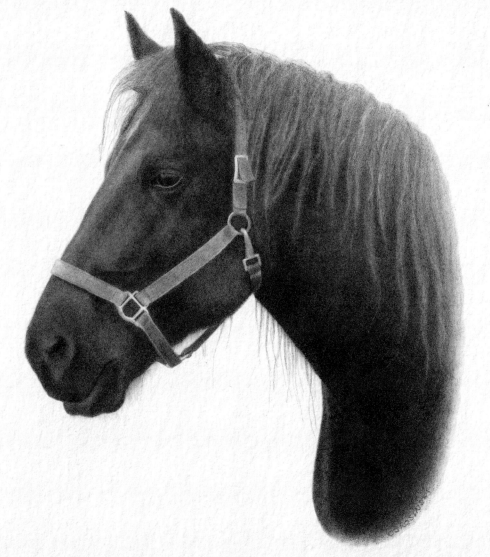

STEP-BY-STEP EXERCISES

WITH CAROL ROSINSKI

Pencil drawing is the most simple and basic art form, yet the range of possible expressions is almost limitless. From energetic sketches of figures in action to simple studies of serene still lifes, drawing can capture time and movement, light and shadow, line, texture, and form—and so much more! As a pencil glides across paper, emotions can be recorded and memories preserved.

Drawing is affordable—a pencil, a piece of paper, and an eraser are all you need. And drawing is a skill that can easily be developed. Mastering the basic techniques is easier than you may imagine. With a willingness to learn and time to devote to practice, your efforts will be rewarded with a new way to express yourself.

—*Carol Rosinski*

TEDDY BEAR

Texture can be broken down into patterns of light and shadow, making the texture easier to reproduce on paper. When drawing a large textured area, use this sequence of actions: hatch and blend the middle value of each area; hatch and blend the large shadow areas; pull out the large highlighted areas with an eraser; draw in the small and dark details; and use an eraser to pull out the smallest, lightest details. This step-by-step exercise will help you focus on replicating the soft fur of a teddy bear. You'll need 2B, B, and 2H pencils; a kneaded eraser; and small and large trimmed brushes for this project.

Step 1 Block in the basic outline of the subject using a B pencil with medium pressure, taking care not to dent or score the paper.

Step 2 Using medium pressure and a dull B pencil, hatch in the middle values of each area. Keep the values relative to one another.

Step 3 Stroke over the entire drawing and smooth it using different sized brushes.

Step 4 Hatch in the large facial shadows to a value of 6 (see below) with a dull B pencil. Perform the same process on the muzzle and bow, using a 2H pencil and very light pressure.

Step 5 Smooth the hatching again with a brush, blending just enough to produce a soft and fuzzy appearance. Work the same way on the bow and muzzle, using very slight pressure on the brush.

Step 6 Shape your kneaded eraser to a rounded point to lift out highlights. If you lighten an area too much, re-darken it by rubbing the brush back and forth over the highlight.

VALUE SCALE

For the projects in this chapter, please refer to the scale below.

1	2	3	4	5	6	7	8	9	10

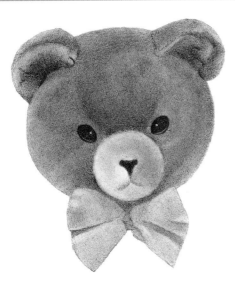

Step 7 Use a sharp 2B pencil to draw dark details, including the bear's eyes, nose, ears, and muzzle. Switch to a sharp B pencil to create the dark details on the muzzle and bow. To achieve these dark values, stroke over the soft areas with a sharp, hard pencil. To finish, carefully lighten the highlights under and in the eyes with a kneaded eraser pinched into a fine point.

Step 8 Draw the rest of the plush body in the same manner as the head, starting with an outline and building up the values and textures in layers. The cold-press watercolor paper with a slightly rough texture contributes to the plush look of this teddy bear. The recessed areas of the paper catch the graphite, creating a pattern that mimics the soft, furry quality of the material.

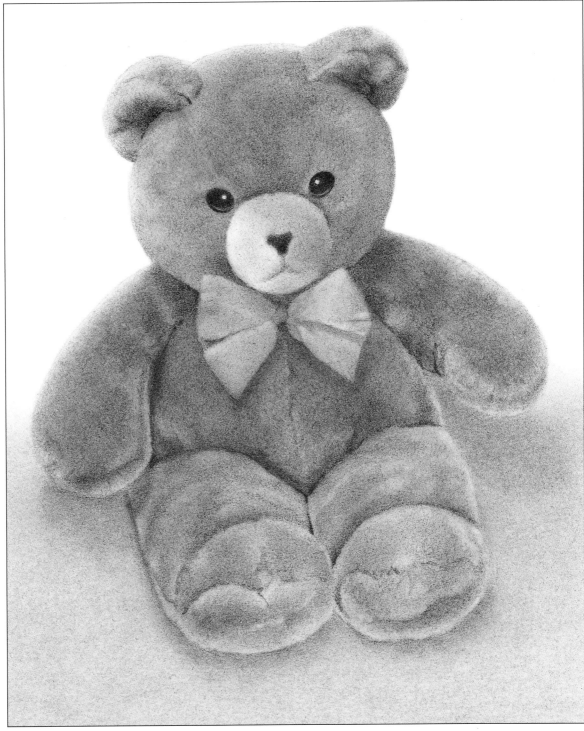

LANDSCAPE

One photographic reference for this dramatic landscape scene captures an interesting sky, and the other presents a pleasing foreground. Merging these elements creates a better composition with a soft feel and subtle gradations in value. To best depict these qualities, use smooth paper without much texture.

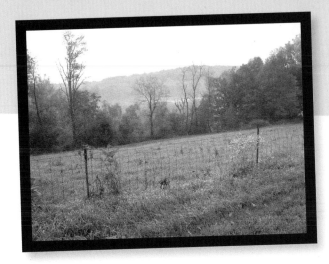

Capturing Contrasts This photo, taken near Shavehead Lake in Michigan, includes a range of values, textures, and lines—from the detailed foreground to the distant hill.

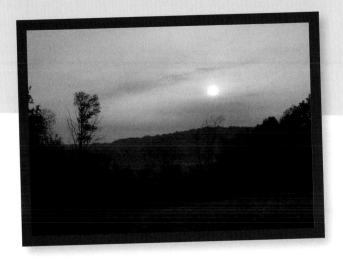

Pulling Out the Sky This photo, taken from the same spot, captures the drama of the sun veiled by sheets of soft clouds. This project combines these two photos.

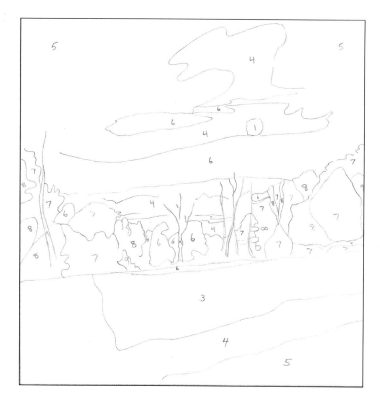

Step 1 Measure and frame the scene, roughing in a few details. Designate certain prominent trees to serve as reference points and also add the most obvious dark tree trunks. Then delineate the trees, meadow, and sky according to the differences in value. Once this "map" is in place, assign a number value to each section, using the value scale on page 120 as a reference.

Step 2 Mask the edges with tape to keep them clean and neat. Using loose graphite and a short, wide brush, fill in the entire sky area to a number 4 value. Brush the graphite down over the skyline and into the treetops, and smooth the sky with a tissue, avoiding the sun. Do the same for the meadow, working from a value number 5 in the bottom right and gradating to lighter values.

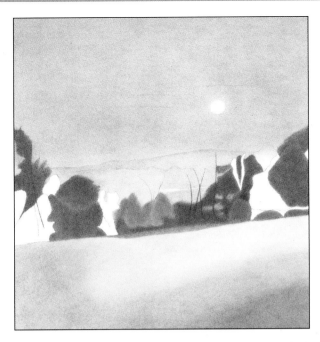

Step 3 Fill in the light- and middle-value trees using smooth hatching made with medium-soft pencils. Brush over the hatching after each layer to help even out the tone, repeating this process until each tree reaches the desired value. Then lightly rub the tree shapes with a tissue wrapped around your finger for an extra smooth texture.

Step 4 Using smooth hatching (see page 9), fill in the darker tree shapes and smooth each area with a brush. Where two or more trees touch, darken one edge to push it back. Next brush loose graphite over the darkest parts of the drawing, repeating until you achieve the darkest value your paper allows.

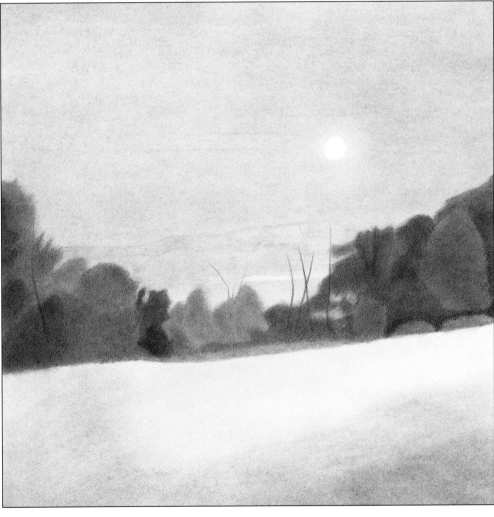

PENCIL KEY

Because pencil hardness varies from brand to brand, the exercises and projects in this chapter generically call for "hard" or "soft" pencils. Use the conversions at right to help determine which pencils to use in the projects of this chapter.

- Very hard: 4H–6H
- Hard: 3H–4H
- Medium hard: H–2H
- Medium: HB–F
- Medium soft: B–2B
- Soft: 3B–4B
- Very soft: 4B–6B

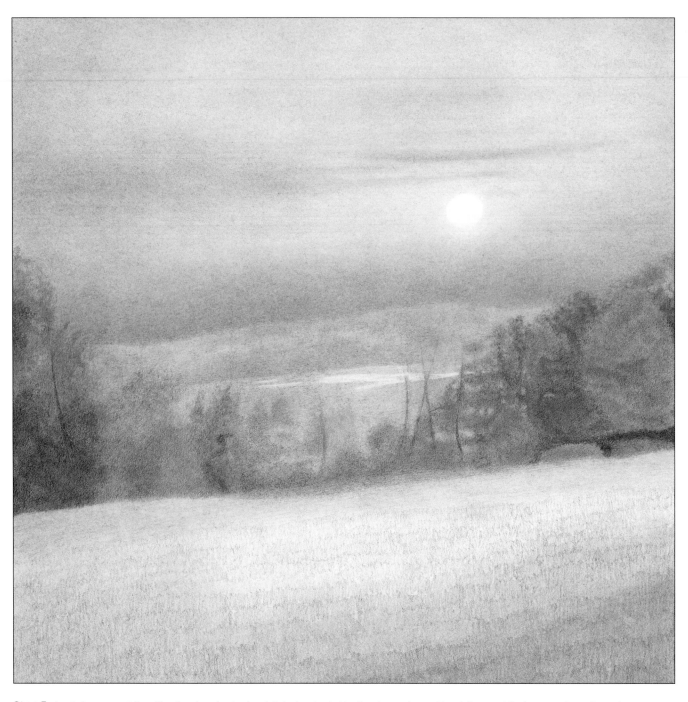

Step 5 Apply loose graphite with a brush, using horizontal strokes to darken the sky, and smooth out the graphite by sweeping a tissue in a horizontal motion over the entire area. Then darken the distant trees and swamp area to a number 5 value using a hard lead and horizontal hatching, taking care to leave the tops of some of the tree clumps lighter for easy identification in the next step. Darken the sky above the hills with a hard pencil to help separate the tree line from the sky. Using the point of a stick eraser, shape and lift out the water visible in the swamp area. Then pinch a kneaded eraser to a point and use it to lift out all the highlight areas of the middle-ground trees. Prepare the base for the grass texture in the foreground meadow by applying rough vertical hatching with a medium-soft pencil.

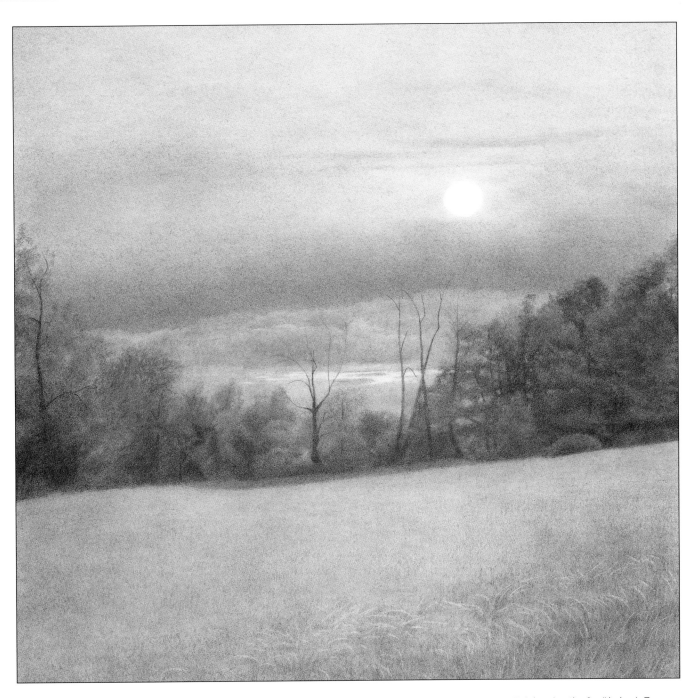

Step 6 Mottle the clouds using very hard pencils and a clean blending stump, and then complete the sun (see "Brightening the Sun" below). To further define the treetops, redraw the skyline with a series of scalloped strokes; then darken the branches and twigs (see "Creating Twigs" below). Soften the meadow by blending the hatching from step five using a stump held on its side. Using the point of a stick eraser, stroke blades of grass in the foreground; then add subtle shadows to the base of the clumps with a medium-soft lead.

Creating Twigs To render the dark, thin lines of the tree branches, use a soft pencil honed to a sharp point.

Brightening the Sun To form the sun, pull out graphite with a kneaded eraser, leaving an imperfect circle for a realistic appearance through the clouds.

HORSE

This sturdy black horse's mane falls on either side of his neck in twirling tendrils, providing an interesting contrast to his robust features. To render this abundance of textural details, work with watercolor paper that has a medium tooth, which will hold dark values and allow a supple look to be created for the coat.

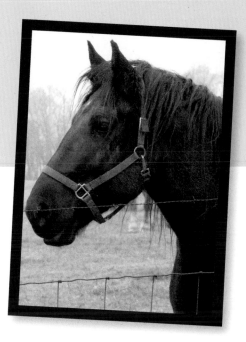

Distinguishing Values The values of the horse shown here are mostly dark, so there won't be much contrast. So that portrait won't be too monotonous, lighten the mane a bit in the drawing.

Step 1 First block in the general shape of the horse's profile on a large piece of paper, taking care to maintain the same proportions as the reference. Take a bit of artistic license and lengthen the back of the neck for balance.

Step 2 Now indicate the eye, nose, mouth, and ears, constantly measuring and assessing the angles of each position; adjust them as you see fit. Then sketch the halter and define the shape of the chin and jaw. Add the brow ridge at left, noting how it angles away from the face; then draw the forelock (the hair between the ears).

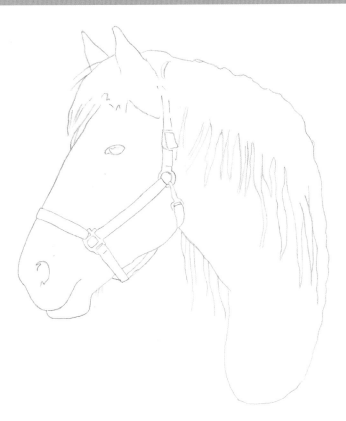

Step 3 Using your initial blockings as a guide, refine the outlines of the eyes, nostrils, muzzle, and mane. Next focus on the halter, curving the lines of the straps slightly so they show the form of the horse's head. Then erase any initial guidelines that you no longer need. Draw the horse's mane, adding tendrils that taper to a point. Round off the neck with a long horseshoe shape that contrasts with the angular quality of the horse's profile.

Step 4 Now transfer the drawing to a separate sheet of paper, and take note of the values based on the reference image. (You may want to use a photocopy of your drawing from step three instead.) Start by outlining the highlights and shadows on the horse's coat; then further delineate the variations in value. Next designate a value number to each area, using the value scale on page 120 for reference.

Step 5 Return to your original drawing and use a medium-soft pencil to fill in the lighter value in the horse's neck and a soft pencil to add the darker value. Hatch the area, and then smooth the hatching with a brush. Repeat those steps until each area reaches the desired value. Where the neck joins the body, lighten the hatching to delineate the area.

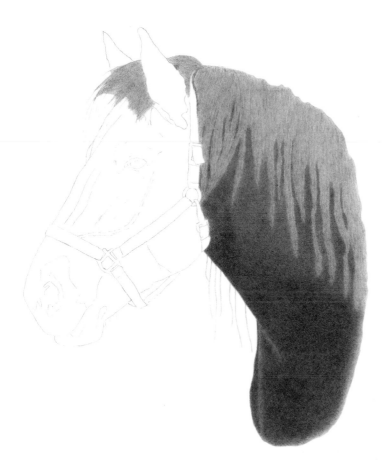

Step 6 Use a medium-hard pencil to fill in the mane. Determine what grade of pencil and combination of strokes will work best for the mane by experimenting on a separate piece of paper that has the same texture as your final drawing. Apply varied long and short parallel strokes, deliberately leaving visible streaks within the vertical hatching to create a base for the mane's texture. Fill in the forelock in the same manner.

Step 7 Fill in each value area with hatching and smooth it out with a brush until it matches the desired value. If a value becomes too dark in an area, use a kneaded eraser to pull out the graphite. Round the extension of the neck even more and continue to fade the edge. Pull out highlights in the metal parts of the halter with a kneaded eraser.

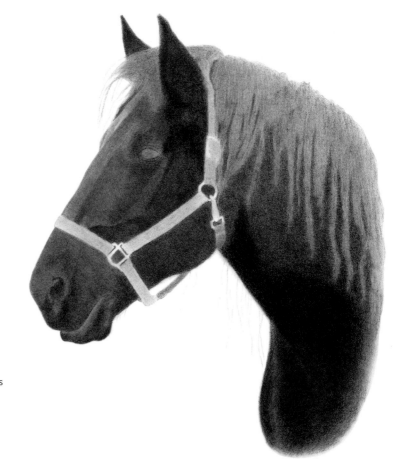

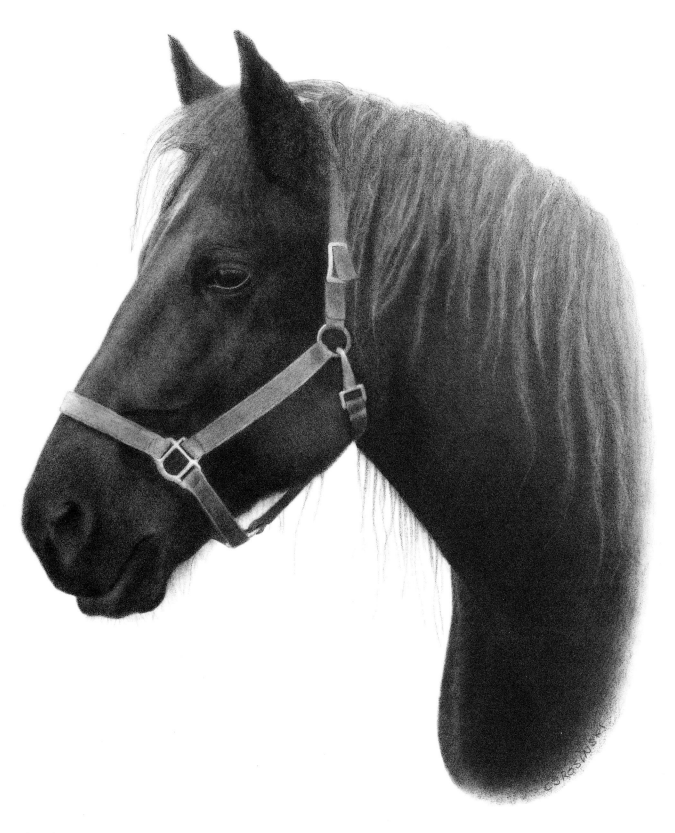

Step 8 Soften the texture on the cheek and neck, blending to draw more attention to the wispy mane. Then pull the medium-hard pencil over the mane with long strokes that follow the line of each twisting strand, making some areas darker for variations in depth. To finish the mane, add twisting highlights to some of the strands of hair, using a stick eraser cut into a point. Darken the far strands of hair and add a bit of fuzz on the horse's chin. Add the final details, including the shadows and stitching on the halter.

FLORAL STILL LIFE

When creating a flower arrangement, follow the rules of effective composition that you learned in Chapter 2. In this arrangement, the vase is slightly to the left to avoid a stagnant, overly symmetrical organization of the elements. Draped fabric curves around the base of the vase, bringing it off the opposite edge of the composition to lead the viewer's eye into the drawing. Some flowers lay on the table to give an informal touch to a classic subject. Lastly, the fabric in the background creates interesting folds and curves in the negative space.

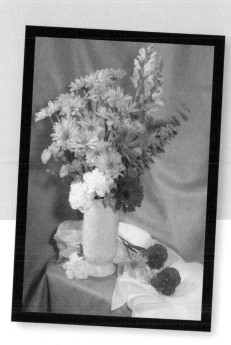

Creating Large Areas of Texture For this mixed floral arrangement, use paper with a medium-rough texture; the tooth helps create interest within the large fabric background and makes the leaf and petal textures easier to render.

Step 1 For a complicated subject like this floral arrangement, block in the basic shapes of the largest objects before adding the smaller elements. To establish accurate proportions, use the vase as a reference for measurement. (In this case, the main bunch of flowers measures 1¾ vases high and wide.) Then loosely sketch the corner of the table and some of the large flower shapes within the bouquet and on the table.

Step 2 Add the rest of the flowers by simplifying their forms, indicating only a general outline; you will add details later. After outlining every object, erase any initial sketch marks you don't need. Then transfer the outline (or make a photocopy) and break each object down into values. Create a "map," referencing the value scale on page 120 to assign a value number to each area.

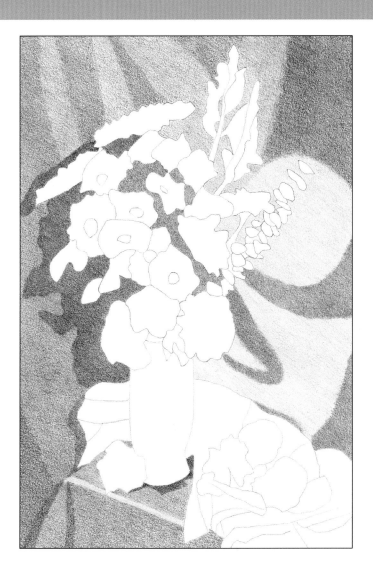

Step 3 To protect the edges of your drawing from smudges of graphite, mask the edges with tape. Then use a soft lead to lay down the hatching in values that correspond with your "map." Crosshatch the darkest shadows first; then add a layer of hatching over the entire background to unify the darks and lights.

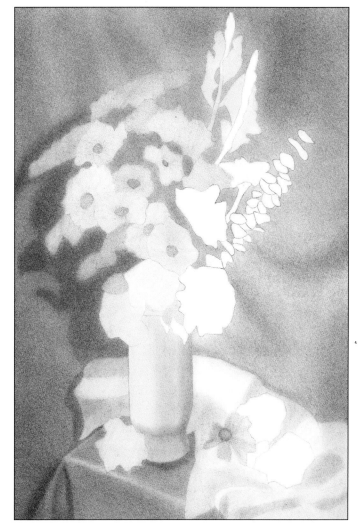

Step 4 Smooth the entire background with a tissue. To work in the negative space between the flowers, fold the tissue several times and use one thick, pointed corner to smooth the hatching. The crosshatched shadows will remain darker than the single-hatched areas. Hatch the light flowers with a medium-hard pencil, following the shape of the flower's petals. Add the flower centers with a softer lead; then add values to the vase and tissue paper on the table using a brush and loose graphite.

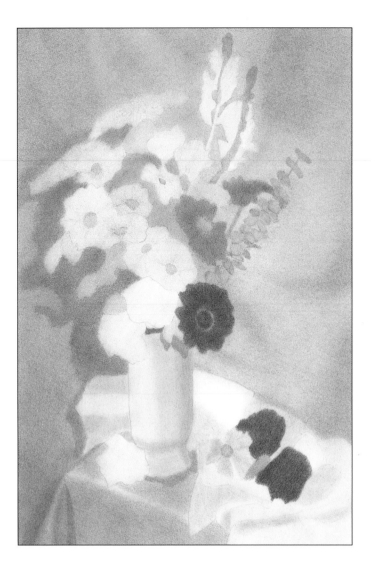

Step 5 Now add the middle- and dark-value leaves and flowers. Begin by hatching the stem and leaves on the right with a medium-soft pencil, blending with a brush for a soft, even value. Next apply horizontal hatching with a soft pencil over the carnations and the dark daisies; then blend the strokes with a brush. If any lights are lost in the blending process, pull them out with a kneaded eraser.

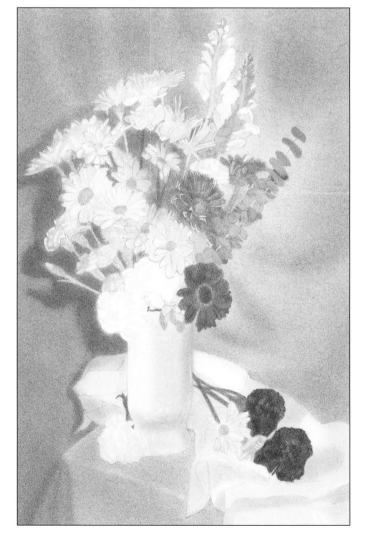

Step 6 Now that you've established the basic value pattern, begin to add detail and give form to the elements. Shape the petals of the flowers by drawing into the edges of the flower shapes or by using a stick eraser to "push out" edges. Then use the same eraser to lift out highlights on the petals, as well as to pull out stems from the background. Use a medium-hard pencil to add more accents to the petals and flower centers.

Step 7 Now add the raised pattern to the vase by further smoothing the gradation of value and pulling out the design with a kneaded eraser. Then lightly add shadows beneath the highlights of the raised area. As you proceed, hold your drawing at arm's length to check and adjust values. Heighten contrasts by erasing to form lights and penciling in darks until you are satisfied.

PORTRAIT OF A GIRL

The adult human face features universal proportions, and subtle variations of these proportions create a likeness of a particular individual. Imagine a rectangle surrounding a face: The eyes are located about halfway down the center and are positioned about one eye-width apart; the bottoms of the ears line up with the bottom of the nose; and the corners of the relaxed mouth line up vertically with the pupils. A child's facial proportions are slightly different than an adult's, as they haven't yet "grown into" some of their features. Children's eyes are farther apart, and their noses are broader, flatter, and shorter. Their eyebrows usually are centered halfway down the head.

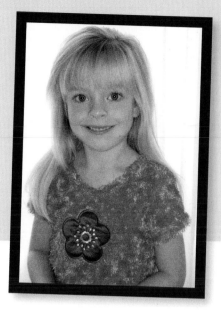

Paper Choice for Emphasis Smooth paper will accentuate this child's youthful and flawless complexion, as it will allow the subtle gradations necessary to replicate her skin.

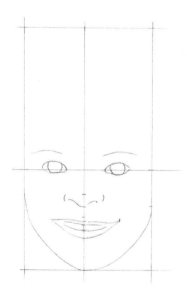

Step 1 Begin by marking the width and height of the face on your paper, and then use these marks to create a rectangular framework for the face. Indicate the position of the major features with dashes, taking care to maintain accurate proportions. Then lightly sketch in the features.

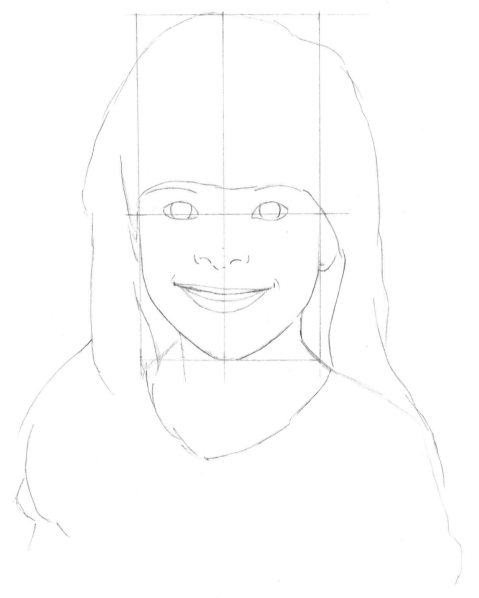

Step 2 Lightly sketch in the hair, sweater, and neck, using the rectangle as a guide for placement. The right side of the neck flows into her jawline, and the left side flows out midway between her bottom lip and chin. Continue to use comparisons for size and placement of the features.

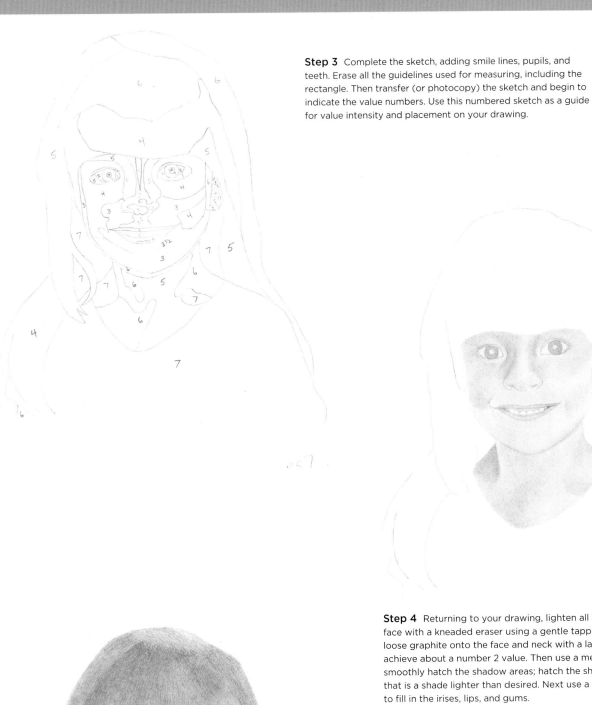

Step 3 Complete the sketch, adding smile lines, pupils, and teeth. Erase all the guidelines used for measuring, including the rectangle. Then transfer (or photocopy) the sketch and begin to indicate the value numbers. Use this numbered sketch as a guide for value intensity and placement on your drawing.

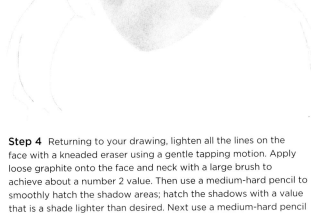

Step 4 Returning to your drawing, lighten all the lines on the face with a kneaded eraser using a gentle tapping motion. Apply loose graphite onto the face and neck with a large brush to achieve about a number 2 value. Then use a medium-hard pencil to smoothly hatch the shadow areas; hatch the shadows with a value that is a shade lighter than desired. Next use a medium-hard pencil to fill in the irises, lips, and gums.

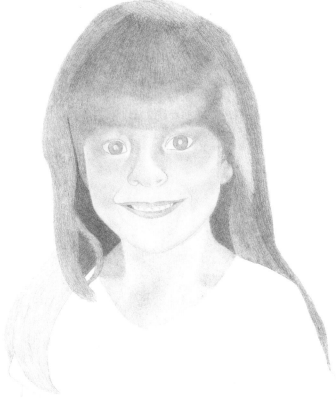

Step 5 For the hair, match the middle value by hatching with medium-soft pencils. Stroke in the direction that the hair grows so that the pencil marks help to create the proper texture. The hair is not as important as the facial features in a portrait, so you can use minimal detail. Simply hint at the hair's mass by laying down the basic values, pulling out the highlighted areas with a kneaded eraser.

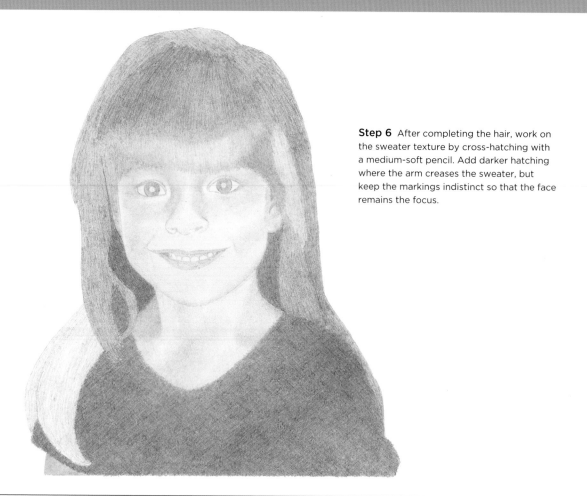

Step 6 After completing the hair, work on the sweater texture by cross-hatching with a medium-soft pencil. Add darker hatching where the arm creases the sweater, but keep the markings indistinct so that the face remains the focus.

DRAWING THE EYES

Step 1 Use a medium-soft pencil to outline the iris, pupil, and lids. Then indicate the curvature of the eyebrow and the edge of the nose.

Step 2 The "white" portion of the eye is a number 2 value, so darken the entire area accordingly using a brush and graphite powder.

Step 3 Using a medium-hard pencil, lightly hatch in the shadow areas around the eye, including the upper lid and the top of the cheek.

Step 4 Darken the outline of the eye and iris, radiating the strokes outward from the pupil. Then darken the shadows using a brush, loose graphite, and a stump.

Step 5 Outline the iris and fill in the pupil, working around the highlight. Smooth the iris with a stump; then darken the eyebrow and corners of the eye.

Step 6 Use a soft pencil to stroke in the upper eyelashes, followed by the lower lashes with a hard pencil. Pull out highlights in the corner of the eye.

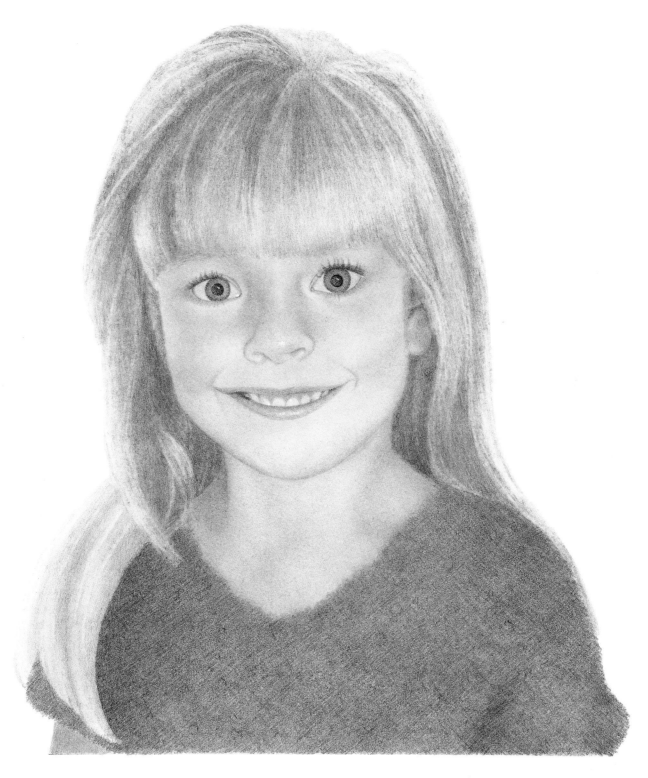

Step 7 Use a brush and a stump to gently rub and stroke the hatching, darkening and smoothing the skin. Graduate the values along the nose and add a highlight on the tip using the sharp point of a battery-powered eraser. Use a medium-soft pencil to add dark details to the eyelids, pupils, irises, nostrils, and corners of the mouth. Then lift out a highlights in the corner of the left eye, on the bottom lip, and on two of the teeth. Finally, smooth the texture of the hair and add thin highlights with a kneaded eraser formed to a point.

FRUIT & WINE

When using only pencil—essentially a range of grays—incorporating contrasts of texture and value into your drawings is important for creating interest. In this scene, the sharp, crisp highlights on the wine glass, bowl, and pieces of fruit nicely contrast against the soft, velvety fabric background. Also the light values of the pears and grapes are a great complement to the dark background.

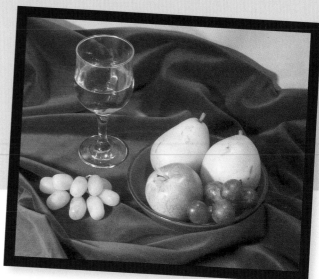

Choosing Paper The soft folds of the fabric and sleek surfaces of the fruit's skin call for a smooth watercolor paper.

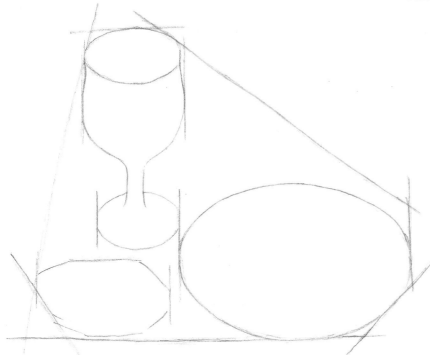

Step 1 Using the technique on page 13, measure the height and width of the triangular composition formed by the wine glass, grapes, and bowl of fruit. Transfer this basic shape to the center of a large piece of paper. Then block in each element of the scene. Because the viewpoint is high, the circular shapes of the bowl and wine glass become ovals.

Step 2 Now begin refining the outlines of each element. Indicate the level of the wine in the glass and each grape in the cluster below the glass. Then add the edge of the bowl, and sketch the fruit, taking care to maintain the proportions shown in the reference photo. When everything is in place, erase the initial guidelines.

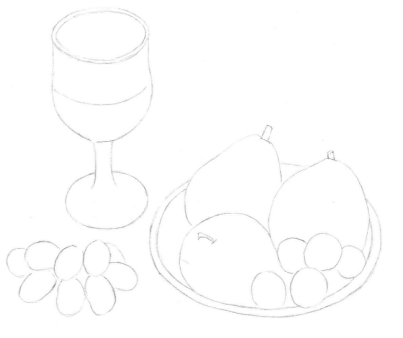

Step 3 Next draw the upper curve of the cloth, noting how far it is above both the glass and the bowl in the reference. Then draw the wrinkles and folds of the cloth. When you are finished, transfer the drawing onto another sheet of paper (or photocopy the sketch) and assign a value number to each area.

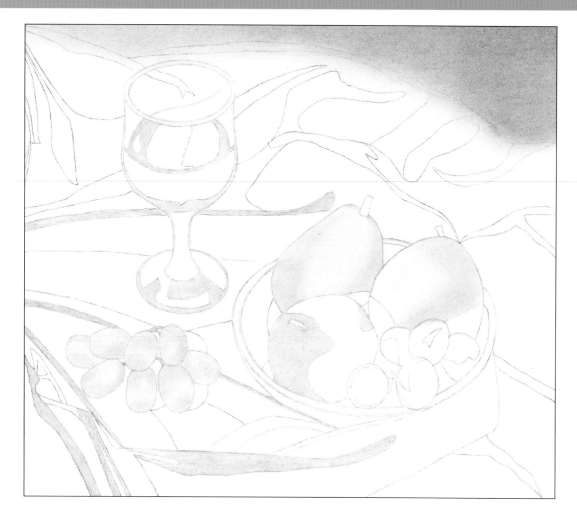

Step 4 Prepare a pile of loose graphite and fill in the far wall (at top) using a wide brush. Graduate to a slightly darker value on the right side to add interest to the negative space. Take your strokes down past the top of the fabric to make it appear as though the fabric is in front of the background. Then add a range of medium and light values in the folds, on the fruit, and in the glass using a smaller brush and loose graphite.

Step 5 Apply darker values to the composition, bringing form to the fruit and further establishing the folded pattern of the fabric. Use medium-hard and soft pencils, depending on the value. Hatch each area, smoothing the hatching with a small brush and repeating the process until the area reaches the desired value.

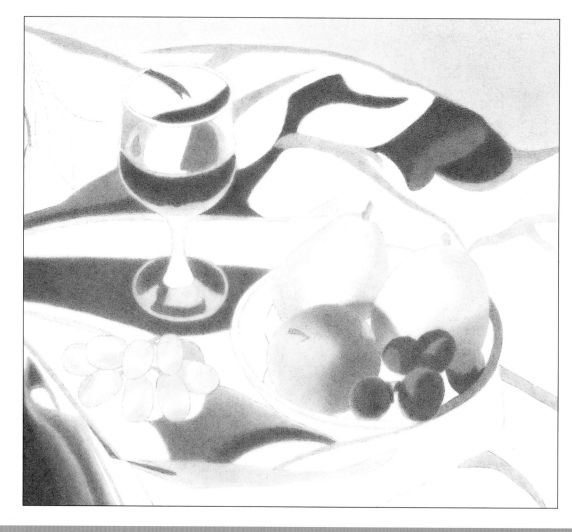

CREATING A WINE GLASS

Step 1 Draw the outline of the glass, and then squint your eyes to see the shapes of the values in it.

Step 2 Use tight hatching to fill each area with a range of dark and medium values.

Step 3 Smooth the separations in value using a small brush. Then begin hatching and smoothing the darkest areas of the wine glass.

Step 4 Add details using a sharp soft lead for the shadows along the base of the glass and within the stem. Then lift out highlights with a stick eraser, accenting the edges of the glass for a sharp contrast to the dark cloth.

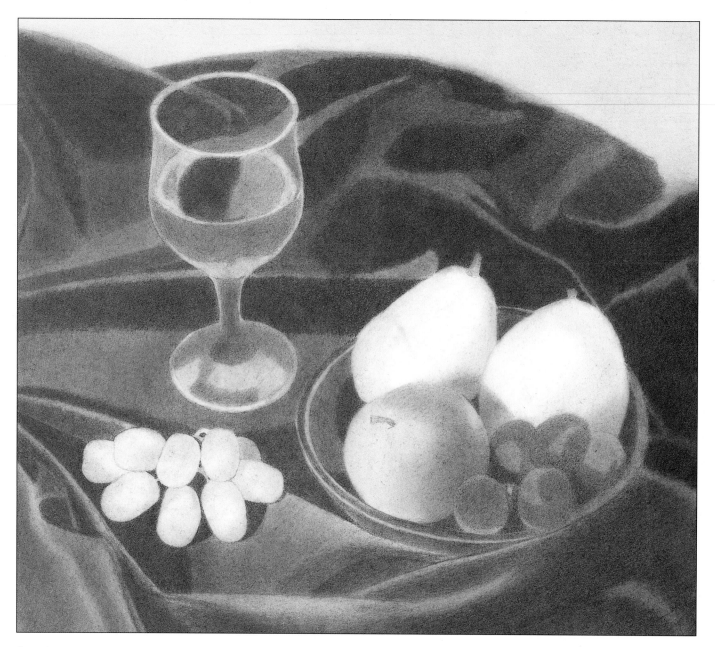

Step 6 To create the very dark values in the surrounding cloth, use sharp, very soft leads for hatching. Follow each layer of hatching with a brush to smooth out the lines, repeating this until you achieve the darkest darks. Because it's possible to lift graphite by brushing it, keep your brush smoothing to a minimum as you approach the final value.

TIP

When applying graphite dust directly to your drawing surface, use several brushes: a small one for little areas that require cleaner edges, and a larger one, which doesn't require as much control of the bristles, for bigger areas.

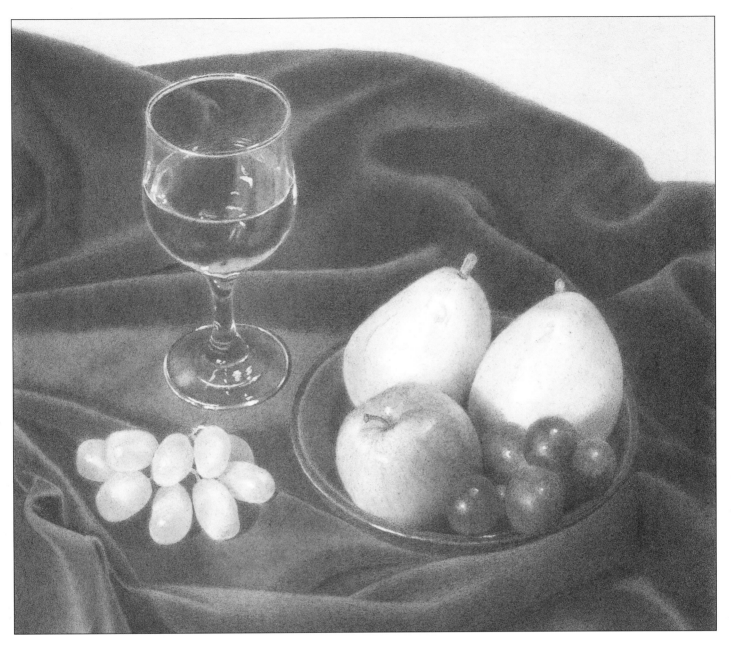

Step 7 In this step, gradually blend the dark areas of the cloth into the highlighted areas of its folds using soft leads and a brush. The dark grapes are similar in value to the bowl, so pay careful attention when separating the grapes' edges from the bowl and from one another. Looking carefully at the shadows that the lighter grapes are casting on one another, apply more graphite to the bodies of the grapes using a small brush. Add a grainy texture to the pears with hard lead followed by light brushing. For the apple, use a kneaded eraser to lift out highlights and a hard lead to add subtle dark stripes. To finish the drawing, create the sharpest contrast possible by pulling out crisp highlights on the fruit, bowl, and wine glass with a battery-powered eraser.

ABOUT THE ARTISTS

Ken Goldman is an internationally known artist, author, teacher, and art juror. A recipient of numerous awards, Goldman has exhibited widely in various group shows and solo exhibitions in the Netherlands, Paris, Italy, Greece, China, Colombia, Mexico, China, New York, Boston, and Washington, D.C. In California, Goldman has shown at the Oceanside Museum of Art, USC Fisher Museum of Art, and Autry Museum of the American West.

William F. Powell was an internationally recognized artist and one of America's foremost colorists. A native of Huntington, West Virginia, Bill studied at the Art Student's Career School in New York; Harrow Technical College in Harrow, England; and the Louvre Free School of Art in Paris, France. He was professionally involved in fine art, commercial art, and technical illustrations for more than 45 years. His experience as an art instructor and consultant included oil, watercolor, acrylic, colored pencil, and pastel—with subjects ranging from landscapes to portraits and wildlife.

Diane Cardaci was classically trained at the Art Students League of New York City, Parsons School of Design, and the School of Visual Arts. She began her art career working as a Natural Science Illustrator in New York City, but after studying portraiture, commissioned portrait work soon became an important part of her artwork. She is a signature member of the American Society of Portrait Artists and has contributed writing for the organization's publications. Diane is also a member of the Colored Pencil Society of America, the Graphic Artists Guild, and the Illustrator's Partnership of America.

Carol Rosinski, from an early age, could pick up a pencil and transform paper and pencil into a living scene with depth and texture. Since 1985, Carol has worked exclusively with graphite pencil, and she has more than 30 years of experience. Carol has worked as an illustrator and shown her artwork in galleries, and her drawings have appeared in a number of publications.